Fort Worth

IN VINTAGE POSTCARDS

D1319135

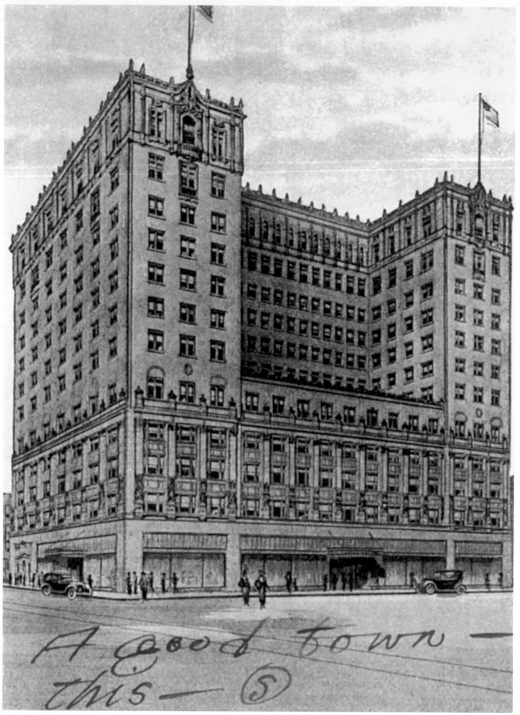

An Oklahoma businessman spent a couple of days in Fort Worth in May 1928—long enough to get a feel for the town and drop a postcard to his friends back home. His opinion, penned neatly across the front of the card, sums up the the opinion most people have about Fort Worth—"A good town—this."

POSTCARD HISTORY SERIES

Fort Worth
IN VINTAGE POSTCARDS

Quentin McGown

ARCADIA

First published 2003
Reprinted 2004

Published by Arcadia Publishing
Charleston SC, Chicago IL, Portsmouth NH, San Francisco CA

Printed in Great Britain.

Library of Congress Catalog Card Number: 2003110958

For all general information contact Arcadia Publishing at:
Telephone 843-853-2070
Fax 843-853-0044
E-Mail sales@arcadiapublishing.com
For customer service and orders:
Toll-Free 1-888-313-2665

Visit us on the internet at http://www.arcadiapublishing.com

CONTENTS

For Laurie . . . for everything.

INTRODUCTION

Fort Worth was established in 1849 as one of a series of military outposts along what was then the western frontier of Texas. The fort was abandoned in 1853 but the civilian settlement that had grown around it stayed on to build a town. Following the Civil War, Fort Worth worked hard to become the major provisioning place for the drovers moving millions of Texas longhorns up the cattle trails to the railheads in Kansas and beyond. The city became a major rail center and, after the turn of the 20th century, one of the busiest livestock markets in the country. The great Texas ranches set up headquarters or branch offices in Fort Worth and when oil was discovered the city became an oil center as well. Defense, aviation, and rail continue to drive the economy. Fort Worth has remained focused on its agricultural past, and through the preservation of the city's western heritage it now attracts millions of visitors from around the world.

When the first images of the city were published on postcards in the late 1890s, several of the buildings and places associated with its 19th century adventures were still standing. In many cases, the postcards provide rare photographic evidence of the period. I began my collection to supplement research on local history and the development of the central business district. As the collection grew it provided an added dimension to the growth of the city and a record of the attractions the publishers found interesting and marketable. So many of the sites that were considered important a few generations ago are still attracting attention: the 1893 Tarrant County Courthouse, restored in 1984; The Livestock Exchange Building, 100 years old in 2003; the Depression-era Texas & Pacific Terminal and Post Office Building, now the centerpieces of downtown revitalization; the Botanic Gardens; Lake Worth; and scores of other structures and places appreciated by residents and visitors alike.

The earliest images were of important civic and commercial buildings: the city hall, the Opera House, and the meat packing plant, each demonstrating to the world that Fort Worth was a successful, modern city, and a center of commerce. Major employers were prominently featured on the first color cards, many produced in Europe. The development of the Fort Worth Stockyards was comprehensively covered by postcard publishers, as were the first city park and a growing downtown with the magnificent courthouse at its head. Over the years some of the most popular subjects were the zoo, the Will Rogers complex, and the local universities. Disasters, from floods to fires, were also memorialized on postcards, as were everyday street scenes depicting Fort Worth life at its routine best. Rare images of the segregated city prior to the 1960s depict churches and, in one case, the home of a prominent and wealthy African American businessman and banker. Addresses and messages on the cards tell us what the senders thought about the city and what they wanted the rest of the world to understand about us.

This book covers a fairly narrow span of Fort Worth's history. The late 19th century starting

point was easy to determine because that's when the first images appeared in Fort Worth. It seemed logical to stop at 1960 for two reasons. First, the city was about to begin another period of transition as it took the first steps toward transforming downtown from a diminishing commercial district into today's vibrant city center, and second, the variety of images began to lessen at that point. Even with the narrow time frame, choosing roughly 200 images from the 2,000 or so published cards and unlimited number of real photo images was a challenge. I have tried to capture some of the broader themes and bigger stories in the city's development. The interpretations and omissions are entirely mine. If I have missed the mark along the way, I'm sure someone will let me know—at least I hope they will!

Fort Worth is very lucky to have a small but growing group of historians working to tell the city's story, and I am indebted to them for the work they have done and for the examples they have set. My sources for this little book ranged from privately printed personal recollections to the tremendous works published and kept alive by TCU Press. I encourage everyone interested in Fort Worth history to add the titles to their libraries. I thank Carol Roark for her gentle push to finally tackle this project I have talked about for so long and for her fact checking to make sure I didn't embarass myself or the city. The book simply would not have ever happened without the guidance and help of James "Mac" McMillin whose expertise and incredible memory for cards have helped so many people build their collections. I appreciate the gracious help of Ken Hopkins and the staff at the Fort Worth Public Library with its outstanding local history resources, and John Moore for lending his critical eye and sound advice. Most important has been the encouragement of my wife Laurie and her amazing patience with my passions.

Quentin McGown
September 2003

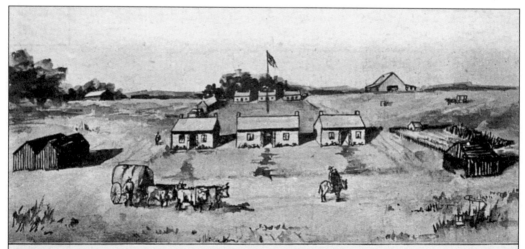

FT. WORTH, TEXAS, in 1853; population, about 40. It is now the home of abou[t] [3]0,000 people and of one of Draughon's Practical Business Colleges (Jno. F. Draughon President). Fourteenth and Main, near the depots.

FORT WORTH IN 1853. Fort Worth was established on June 6, 1849 as part of a line of military outposts along what was then the western frontier of Texas. When John Draughon published this idyllic view of the fort about 1910 to advertise his Business School a few residents of the city still remembered those early days The sketch, by local artist C. MacLean, remained the primary image of the fort until more recent research uncovered new information about the fort and the soldiers who were stationed there.

One
19TH-CENTURY FORT WORTH

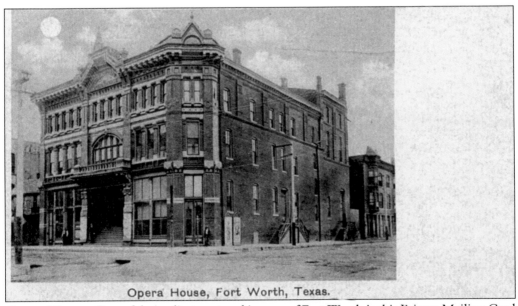

Opera House, Fort Worth, Texas.

OPERA HOUSE. One of the earliest postcard images of Fort Worth is this Private Mailing Card view of the Fort Worth Opera House. Built in 1883 on the northwest corner of Rusk (now Commerce) and Third, it was one of the largest structures in town and stood as a monument to the transition from wild cattle town to modern city. The Opera House was the cultural center of Fort Worth until replaced by a new theatre at Seventh and Commerce in 1906. Among the great performers to play there were Lilly Langtry, Sarah Bernhardt, Edwin Booth, and the Barrymores. (Private Mailing Card, *c.* 1898.)

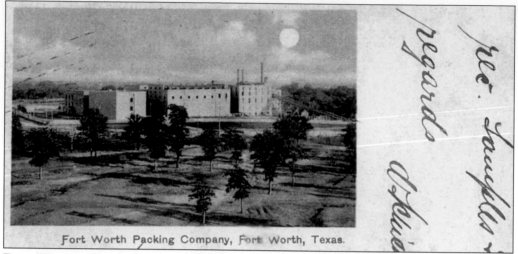

Fort Worth Packing Company, Fort Worth, Texas.

FORT WORTH PACKING COMPANY. An early dream of Fort Worth leaders, as they watched millions of cattle trailed north through the city beginning after the Civil War was to develop Fort Worth as a rail and packing center. The railroad arrived in 1876 and the first packing plant opened in 1883. The Fort Worth Packing Company built the first major plant on the north side, opening for business in November 1890. The plant, and its adjacent livestock pens, would eventually evolve into today's Fort Worth Stockyards. (Private Mailing Card, *c.* 1898.)

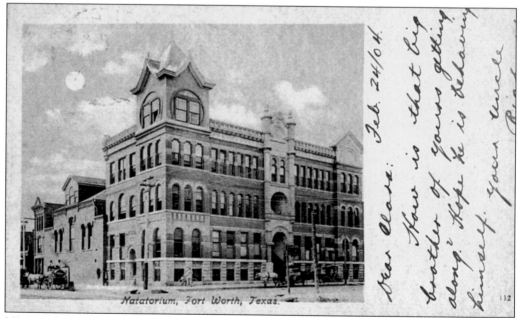

Natatorium, Fort Worth, Texas.

NATATORIUM. At a time that most homes in Fort Worth did not have indoor plumbing the Natatorium was the premier bathhouse in town, providing Turkish and Russian baths, tubs of artesian water and a 95-foot swimming pool. Sam B. Cantey, a successful attorney and partner in the firm of Capps and Cantey, was president of the Artesian Water Company that built the elaborate facility in 1890. Sitting across the street from the Opera House at Third and Rusk (Commerce) the Natatorium also had overnight rooms and could be booked for private parties. (Private Mailing Card, *c.* 1900.)

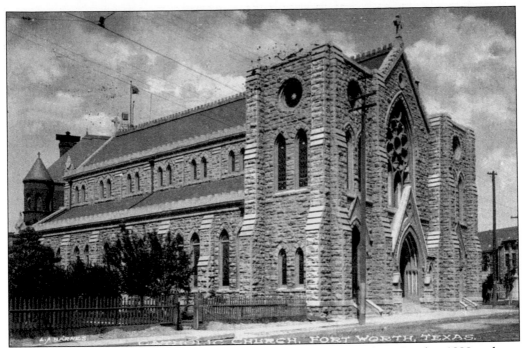

CATHOLIC CHURCH. Construction began on Saint Patrick Church in October 1888 and was completed in 1892. It is today the oldest continuously used church building in Fort Worth and one of the few remaining structures in the city dating from the 19th century. Renamed Saint Patrick Cathedral in 1969, the gothic revival cathedral features beautiful stained glass, some dating from the opening of the church in 1892. Along with the adjacent Saint Ignatius Academy building, Saint Patrick was among the first buildings in Fort Worth designated as a Recorded Texas Historic Landmark. (L.A. Barnes, *c.* 1906.)

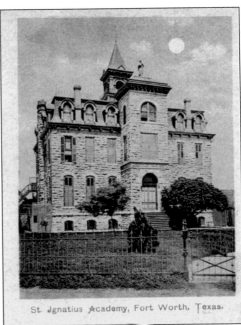

St. Ignatius Academy, Fort Worth, Texas.

SAINT IGNATIUS ACADEMY. The Academy was established by the Sisters of Saint Mary of Namur in 1885. In 1888 they hired local architect J.J. Kane, designer of the adjacent Saint Patrick Church, to craft the still-standing academy building in the French Second Empire style, of which this is the only remaining example in Fort Worth. The Sisters would later, in 1910, build Our Lady of Victory Academy to accommodate the growth of their school operation. Both Saint Ignatius and Saint Patrick were listed in the National Register of Historic Places in 1985. (Private Mailing Card, *c.* 1898.)

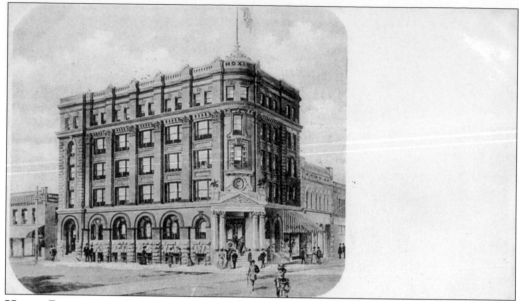

HOXIE BUILDING. John R. Hoxie moved from Chicago to Fort Worth to capitalize on the growing fortunes of the city. In 1889 he organized the Farmers and Mechanics Bank and in 1899 built this imposing five-story office building on the northwest corner of Seventh and Main Streets. Hoxie served as president of the Fort Worth Union Stockyards and was instrumental in the early development of the packing industry that would support the Fort Worth economy for decades. (Private Mailing Card, *c.* 1899.)

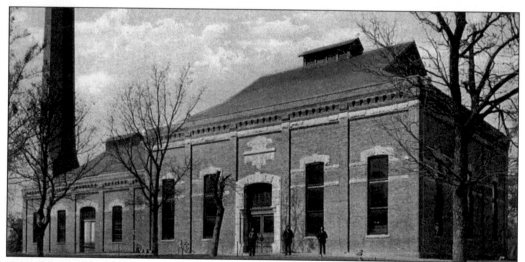

CITY WATER WORKS. Natural springs provided water to the city's earliest residents, but as the town grew it relied more and more on the Trinity River, an unpredictable and often unhealthy source of drinking water. A system of almost 100 artesian wells drilled in 1887 provided a better supply for a time, but it was the construction in 1892 of the new water plant, designed by the Holly Water Works Company, that stabilized supply and quality. The 1892 facility shown here still stands just north of the Lancaster Avenue bridge, although the smokestack is gone and the building was redesigned to mirror the mission architecture of the surrounding water plant buildings. (Souvenir Post Card Co., *c.* 1907.)

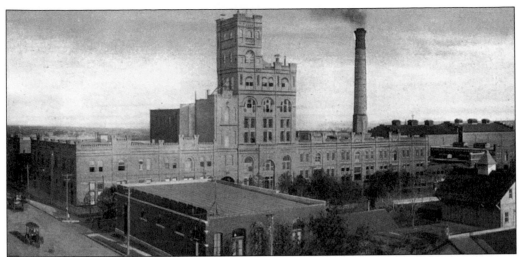

TEXAS BREWERY. The sprawling plant of the Texas Brewing Company covered three city blocks along Jones Street, between Ninth and Twelfth Streets, the site of today's Intermodal Transportation Center. Opening in 1890 the brewery was the city's first major employer. According to Dr. Richard Selcer in his history of Hells' Half Acre—the city's tenderloin district which had its roots in the trail driving days—the Texas Brewing Company produced "enough beer to fill 3,000 freight carts a year," and had an annual payroll of $100,000. The business fell victim to prohibition, and the massive plant was used for storage and small businesses until it was eventually demolished in stages over several years. (Unknown Publisher, *c.* 1907.)

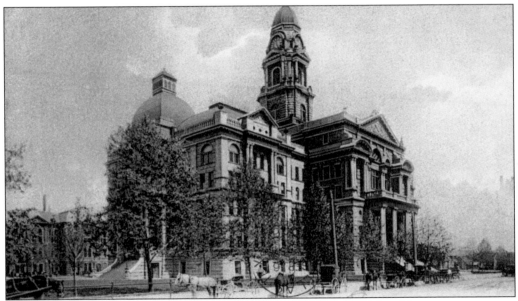

COURT HOUSE. In 1893 Tarrant County voters passed a $500,000 bond issue to construct a grand new courthouse. Fort Worth had become the county seat in 1856 and by 1890 boasted a population of 20,000. The fifth structure to serve as the seat of county government, the 1893 courthouse is the fourth on the present site that was also the location of the 1849 military outpost of Fort Worth. The building was designed by the St. Louis design firm of Gunn and Curtis and was patterned after the 1888 Texas State Capitol. (The Rotograph Co., 1905.)

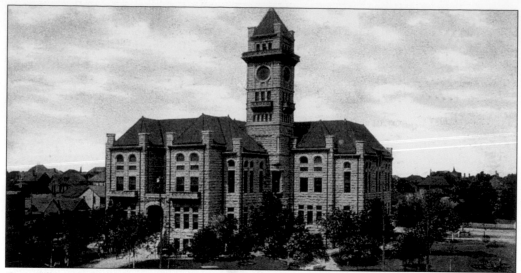

CITY HALL. Following Fort Worth's incorporation in 1873 city government was housed in a variety of buildings near the intersection of Second and Commerce Streets. In 1893, a new city hall was built at Throckmorton and Tenth Streets, where municipal offices have remained ever since. This building was demolished in 1938 to make way for a new city hall funded through the Public Works Administration and local bonds. (Duke & Ayres, *c.* 1905.)

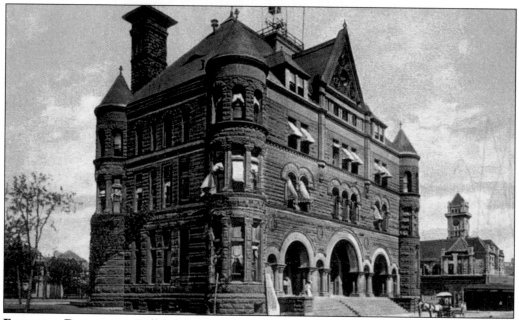

FEDERAL BUILDING. Following nine acts of Congress authorizing and funding its construction, a federal building and post office was built in 1896 on Jennings Avenue, just south of the city hall and across the street from Saint Patrick Church. Among the old building's tenants was longtime postmaster, Mrs. Belle Burchill, who instituted home delivery of the mail. Mounted on the roof of the building was the weather reporting equipment of the United States Weather Bureau. The building was demolished in 1970 to make way for the current Fort Worth Municipal Building. (Grombach-Faisans Co., *c.* 1907.)

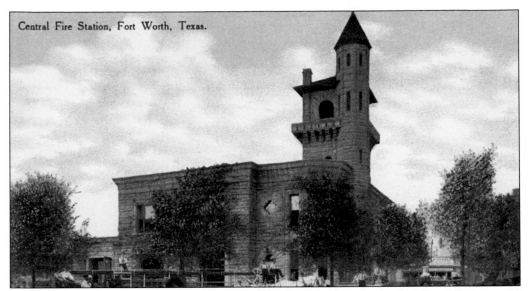

Central Fire Station, Fort Worth, Texas.

CENTRAL FIRE STATION. In November of 1893, Fort Worth authorized its first full-time paid fire department, and in 1899 the Central Fire Station was built in the triangle north of City Hall, replacing a wooden station built nearby in 1884. The pride of both buildings was the 3,000-pound fire bell ordered from New York. Both buildings are gone now, but the bell is displayed outside the present Central Station on Cherry Street. (S.H. Kress, *c.* 1907.)

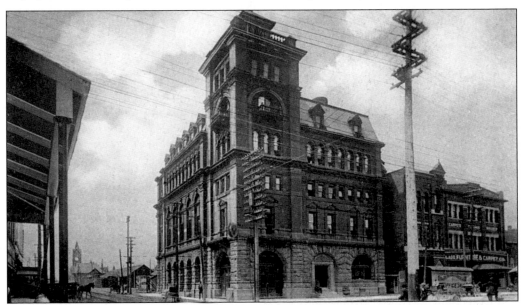

BOARD OF TRADE BUILDING. After an initial and unsuccessful attempt to establish the Fort Worth Board of Trade in 1876, city leaders interested in bringing business to the city created a permanent organization in 1882. In 1889 the board built this building on the northwest corner of Houston and Seventh Streets. In 1903 the Continental Bank and Trust Company occupied the ground floor, eventually growing into the Continental National Bank and replacing the 1889 building with a skyscraper topped with what was for years the world's largest revolving clock. (Rotograph Co., *c.* 1901.)

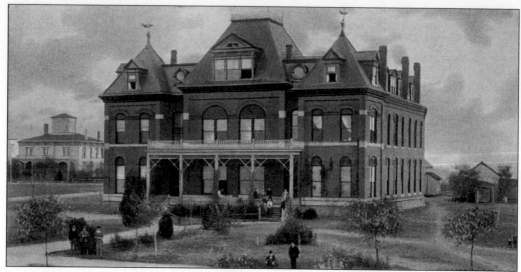

FORT WORTH UNIVERSITY. Established in 1881 as Texas Wesleyan University by the Methodist Episcopal Church, the school moved in 1886 from its original downtown location to a site on the edge of the city limits, just two miles south of the courthouse. Renamed Fort Worth University in 1889, the school offered basic undergraduate degrees as well as professional degrees in medicine and law. The campus sat on the College Avenue site now occupied by Green B. Trimble Technical High School. The university closed its campus in Fort Worth in 1910 but continues its legacy as a component of Oklahoma City University. (Raphael Tuck & Sons, *c.* 1907.)

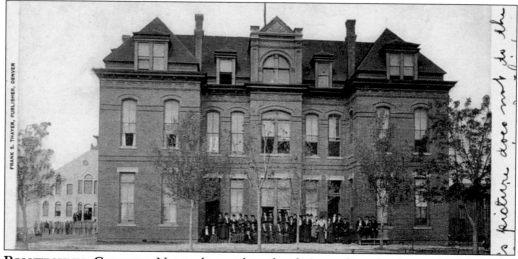

POLYTECHNIC COLLEGE. Not to be outdone by their northern brethren, the Methodist Episcopal Church, South, under the leadership of Bishop Joseph S. Key, established Polytechnic College in 1891. The founders accepted a gift of land on a hill four miles east of town where they could advertise that the campus was a safe distance from the "sins of Fort Worth," a reference to the notorious Hell's Half Acre. The college became Texas Woman's College in 1914 and is today's Texas Wesleyan University. The original building shown here was demolished in 1991 following a fire, and had been the oldest continuously used educational facility in Tarrant County. (Frank S. Thayer, *c.* 1907.)

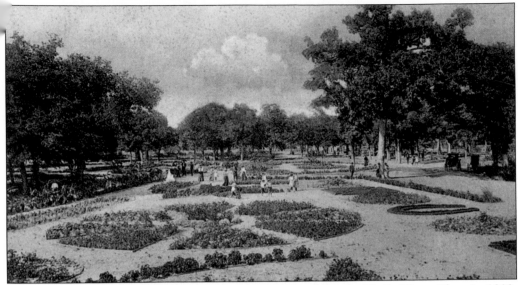

CITY PARK GARDEN. When the city acquired the land for the Holly Water Plant in 1892, it set aside 31 acres to create the first major municipal park. Straddling the Clear Fork of the Trinity River roughly between today's West Seventh Street and Lancaster bridges, the park featured formal gardens, driving paths, and evening entertainments during the summer. Much of the original park was lost when the river channel was moved about a quarter mile west of its original course during the 1930s, but today's Trinity Park still retains remnants of the 1892 design. (Adolph Selige Pub. Co., *c.* 1901.)

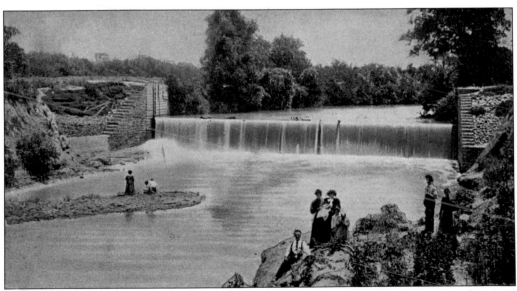

CITY PARK DAM. The central feature of the 1892 City Park was a dam that created a small lake to supply the Holly Water Plant when there was enough water in the river. Demolished when the river channel was relocated, the dam sat under the eastern side of today's West Lancaster Bridge. Tragedy struck during the summer of 1898 when young William Coughlin drowned at the dam in an unsuccessful attempt to rescue his sister Jenny from the deep water. (Raphael Tuck & Sons, *c.* 1901.)

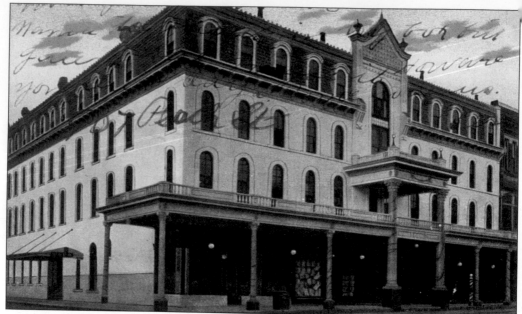

DELAWARE HOTEL. Built on the northwest corner of Fourth and Main, the Delaware opened in 1891 but traced its roots back to the first hotel on the site, the El Paso, built in 1878. The El Paso had been renovated and renamed the Pickwick in 1886, before finally reopening as the Delaware. It was the El Paso Hotel that had been the scene of the asphyxiation of Chief Yellow Bear and the near death of Chief Quanah Parker after the gas light in their room had been blown out instead of turned off. The Delaware was demolished in 1910 to make way for the New Delaware Hotel, quickly renamed the Westbrook Hotel. (Elite Post Card Co., *c.* 1907.)

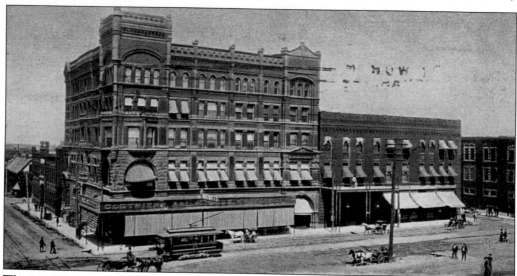

WORTH HOTEL. Cattleman John Scharbauer built what could be considered the city's first luxury hotel, The Worth, in 1894 at Seventh and Main. Developers converted the property into retail and office space when the Texas Hotel opened next door in 1921. The old hotel operated successfully as the Worth Building until it was destroyed by fire in 1945. (Raphael Tuck & Sons, *c.* 1905.)

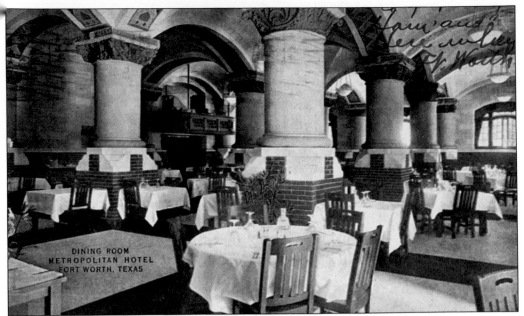

DINING ROOM, METROPOLITAN HOTEL. Among the most storied hotels in Fort Worth was the Metropolitan, opened in 1898 at Ninth and Main by Winfield Scott, at one-time owner of vast tracts of downtown real estate, including the famous White Elephant Saloon. The scene of two nationally reported love triangle murders, first in 1913 and again in 1923, the sprawling hotel grew to take up the entire block. The hotel closed its doors in 1959 before being demolished to make way for the convention center development. (Unknown Publisher, *c.* 1910.)

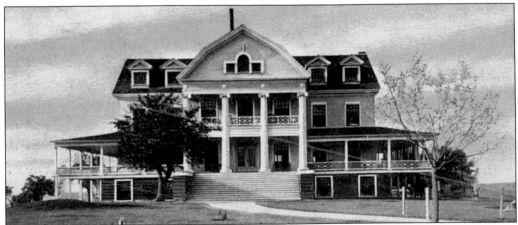

ARLINGTON HEIGHTS COUNTRY CLUB. Not long after an 1895 fire destroyed the monumental "Ye Arlington Inn," a resort built by the promoters of the Arlington Heights Development, a group of local men discussed the idea of building a country club on the site near the present intersection of Merrick and Byers Streets. Among the planners was William Bryce, a native of Scotland who arrived in Fort Worth in 1883 and became the leading builder and contractor in town, responsible for such buildings as the Texas Brewing Company and the Knights of Pythias Castle as well as laying the city's brick streets. He would also serve the city as mayor. The Country Club, designed by Marshall Sanguinet, finally opened in 1902 and was the first golf and country club in Fort Worth. (Unkown Publisher, *c.* 1910.)

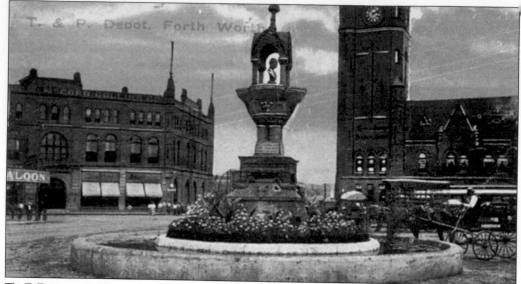

T&P Depot. Still standing at the intersection of Lancaster and Main Streets is the monument to Al Hayne, the hero of the Texas Spring Palace. When the magnificent, but highly flammable, building displaying the bounty of Texas products burned in May 1890, Hayne rescued many people from the flames before he succumbed to the smoke, dying the next day. In 1893 the Ladies Humane Society erected a horse fountain near the train depot in his memory. After the original bust of Hayne, sculpted by local monument carver Lloyd Bowman, was stolen, a replacement bust was commissioned by the Fort Worth Art Association and completed by artist Evaline Sellors. (Unknown Publisher, *c.* 1905.)

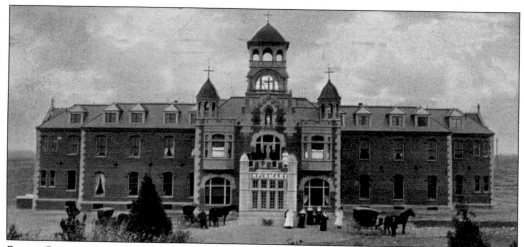

Saint Joseph's Infirmary. Founded in 1889 by the Sisters of the Incarnate Word, Saint Joseph's was the city's first hospital, an outgrowth of an infirmary operated by the Missouri-Pacific Railroad for its employees. The Sisters built this 60-bed facility on a 15-acre tract they purchased at what was then the far outskirts of the city on South Main Street. The Sisters grew their own fruits and vegetables, raised chickens and cows, and kept two horses for the ambulance. Patients paid 90¢ a day if they could, but no one was turned away. The hospital would eventually grow into a 475 bed modern hospital complex before closing its doors in 1995. (Raphael Tuck & Sons, *c.* 1907.)

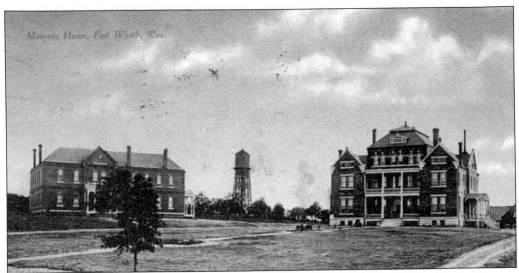

MASONIC HOME. From the founding in 1854 of the first lodge in Fort Worth, the Masons have been heavily involved in the growth and development of the city. On a 200-acre site east of town they opened the Masonic Widows and Orphans Home in 1899 to serve eligible women and children from across Texas. Later renamed the Masonic Home and School, the facility continues to provide exceptional educational and athletic opportunities for residents under the care of the Grand Lodge of Texas. (Unknown Publisher, *c.* 1905.)

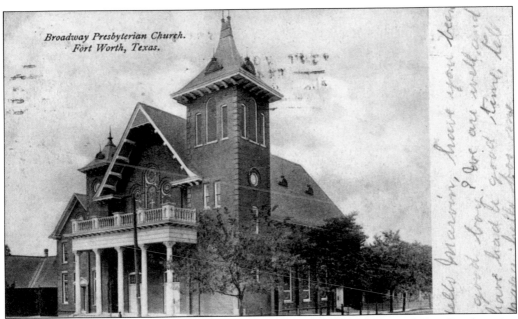

BROADWAY PRESBYTERIAN CHURCH. In 1884 the South Side Mission of First Presbyterian Church was organized as Broadway Presbyterian Church in a small frame building on the corner of Broadway Avenue and St. Louis. In 1899 the congregation hired local architect Howard Messer to design a larger, brick sanctuary that served the church until the building was destroyed in the South Side Fire in April 1909. The congregation rebuilt, but later relocated and renamed itself St. Stephen Presbyterian Church. (Adolph Selige, *c.* 1901.)

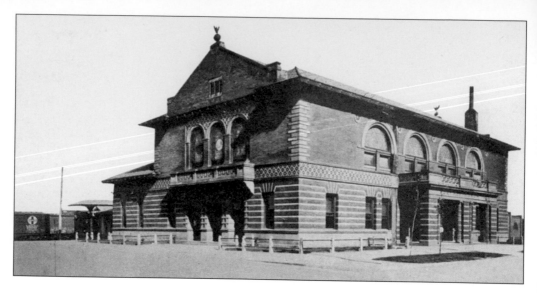

UNION PASSENGER STATION. As Fort Worth looked to the turn of the 20th century, it had seen its dream of becoming a rail center turn to reality. Beginning with the arrival of the Texas & Pacific in 1876, the city could boast of seven railroads coming into town by 1895. Construction began on the new Union Depot on Jones Street in 1899. Designed in the Beaux Arts style, the station featured a massive passenger waiting room adorned on the north wall with tall stained glass panels honoring the history of transportation from wagons crossing the prairies to the then ultra modern steam locomotives. Following the relocation of Amtrak service to the new Intermodal Center, the depot awaits restoration and reuse. It was designated a recorded Texas Historic Landmark and listed in the National Register of Historic Places in 1970. (Fred Harvey, 1908.)

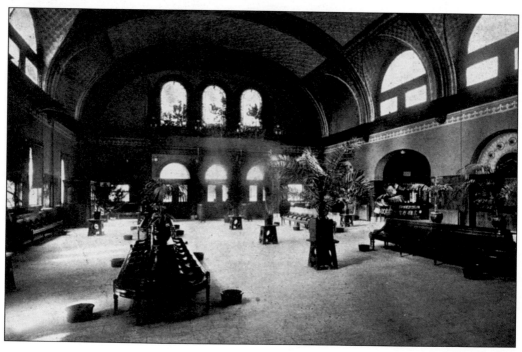

Two
1900–1910

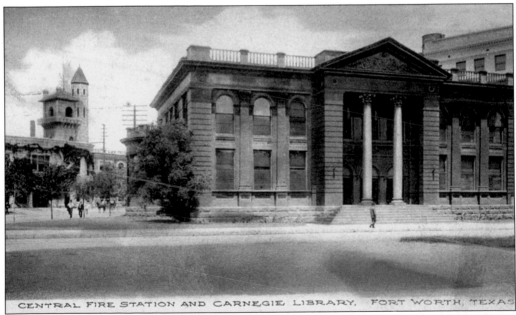

CENTRAL FIRE STATION AND CARNEGIE LIBRARY, FORT WORTH, TEXAS

CARNEGIE LIBRARY. After working unsuccessfully for six years to raise funds to build a library for the growing city, the women of the Fort Worth Library Association decided in 1898 to ask the men of the city to donate the price of a good cigar to the cause. When Mrs. D.B. Keeler took a chance and sent the simple request to Andrew Carnegie, the philanthropist responded with a $50,000 gift. The Carnegie Library, at the corner of Ninth and Throckmorton Streets, opened to patrons in 1900 and served the community until it was demolished to make way for a new library in 1938. (Publisher Unknown, *c.* 1907.)

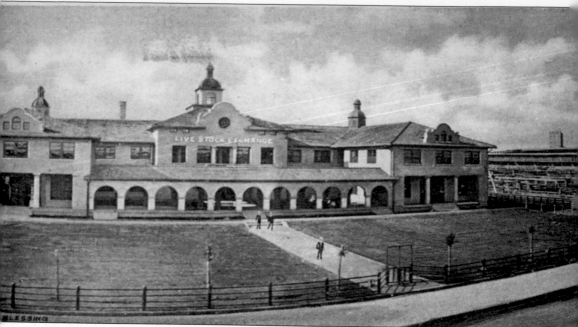

LIVESTOCK EXCHANGE–YARDS AND PACKING HOUSES. Following years of pursuing the dream of the city becoming a meat packing and shipping center, Fort Worth citizens saw the dream become reality when Swift & Company and Armour & Company opened side by side operations in North Fort Worth in 1902. The resulting economic boom that followed the opening of the plants and the expansion of the Fort Worth Stockyards helped the city nearly

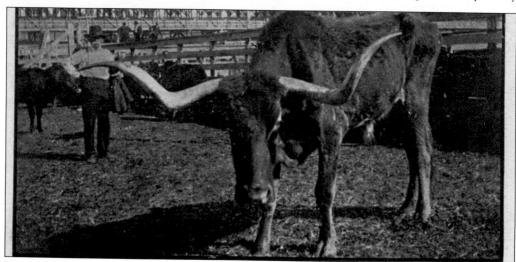

THE ORIGINAL TEXAS STEER. The roots of the Stockyards dated back to 1867 when the first herd of longhorns was trailed north through Fort Worth on the way to the railhead in Abilene, Kansas. Over the next 20 years millions of cattle would make their way through Fort Worth, halting business and choking the city in dust while establishing a solid economy and assuring the city's success after four years of civil war. By 1907 few of the old Texas Longhorns remained when this steer was photographed for posterity. With a horn span of 7 feet 1 inch, the 25-year-old animal stood as a hardy reminder of the trail driving days. (Wyly & Sellars 1907.)

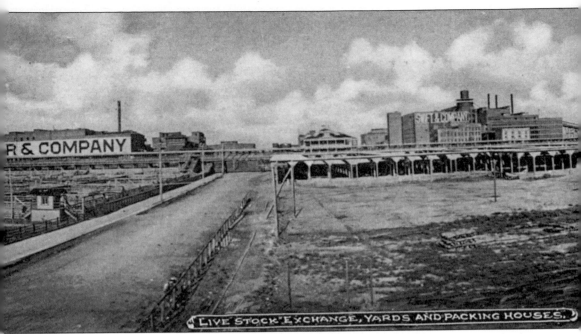

triple in size by 1910, growing to almost 75,000 residents. This early panoramic view looks east on Exchange Avenue shortly after completion of the Livestock Exchange Building in 1903. The plants of Swift and Armour filled the horizon above the wooden stock pens that would be destroyed by fire in 1911 and replaced by the fireproof facilities still in use today. (Blessing Photo Supply Co., *c.* 1904.)

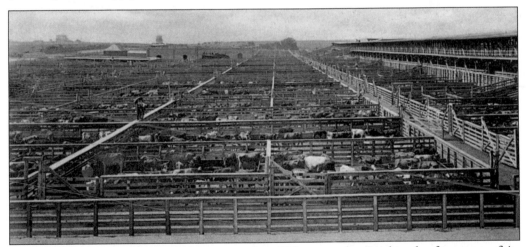

STOCKYARDS. Eventually covering more than 200 acres, the Stockyards, for most of its history, ranked among the top five livestock markets in the country and was the city's largest employer. During the years of World War I, the Stockyards was the largest horse and mule market in the world, and, during its peak year in 1944, more than five million animals were processed. This image, taken about 1904 looks north from Exchange Avenue across the expanse of cattle pens. At right is the elevated walkway that allowed livestock to move from one side of the yards to the other as they were driven to or from rail cars for shipment or to the Swift and Armour plants for processing. (Adolph Selige, *c.* 1904.)

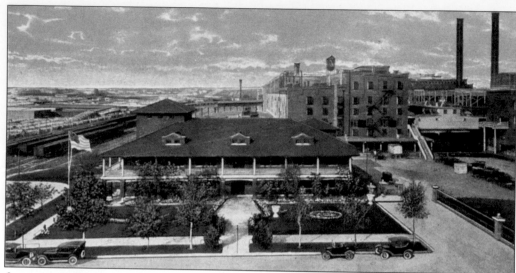

ARMOUR & COMPANY. Attracted to Fort Worth by the land and incentives offered by the Fort Worth Stockyards Company, meatpacking giant Armour & Co. opened its plant in the Stockyards in 1903 in partnership with Swift & Co. Together the companies acquired the majority ownership in the Fort Worth Stockyards and dominated the market for more than 50 years. The massive Armour plant ceased operations in 1961 due in large part to the decentralization of livestock markets following World War II, the growth of remote feedlot operations, and outmoded technology. The headquarters building, shown in the foreground, was demolished shortly after the plant closed. (S.H. Kress & Co., *c.* 1925.)

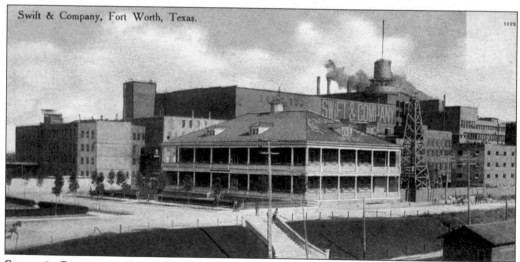

SWIFT & COMPANY. Directly across Exchange Avenue from the Armour complex, Swift & Co. built its own towering packing facility beginning in 1902. Over the next six decades, more than 120 million animals would be processed through the Stockyards providing jobs to thousands of employees, many of whom would ride the streetcar to work and walk up the staircase at the head of the avenue. The columned Swift headquarters, built in 1903, still presides over the Stockyards while it awaits restoration as a major contributor to the Fort Worth Stockyards National Historic District, where millions of visitors have replaced the millions of animals as the area's primary economic base. (Duke & Ayres, *c.* 1910.)

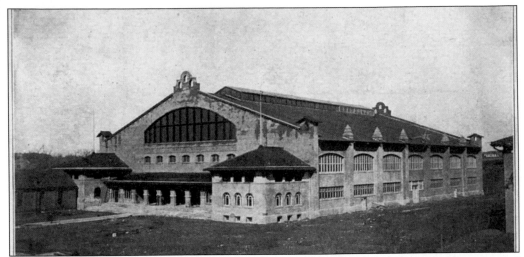

COLISEUM. Ground was broken in September 1907 for a new pavilion to house the renamed National Feeders and Breeders Show, the annual stock show that had begun on the banks of Marine Creek in 1896 and today operates as the Southwestern Exposition and Livestock Show and Rodeo, one of Fort Worth's most important events. Opening in March 1908 the Coliseum was home to the stock show until the show moved in 1944 to the Will Roger Center across town. As the city's primary performance venue for many years, the Coliseum hosted Wild West shows, Billy Sunday revivals, Enrico Caruso, Bob Wills, and Elvis Presley. (George W. Bellar, 1908.)

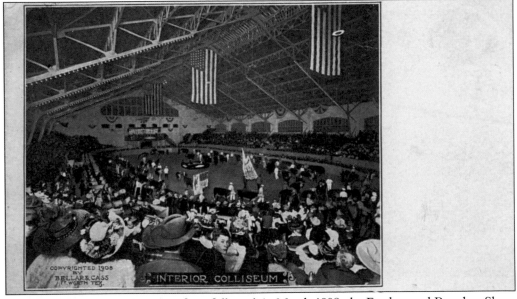

INTERIOR, COLISEUM. Running for a full week in March 1908, the Feeders and Breeders Show filled the new Coliseum with a variety of activities, including the Hereford competition shown in this early image. Also included was "The Wild West and Range Country Life and Expert Riding Demonstration," the forerunner of today's modern rodeo. The show's highlight was the performance by a master showman, African-American cowboy Bill Pickett, whose bulldogging act of "throwing a wild steer with his teeth" is today commemorated on the Coliseum grounds by a bronze statue erected by the North Fort Worth Historical Society. (Bellar & Cass, 1908.)

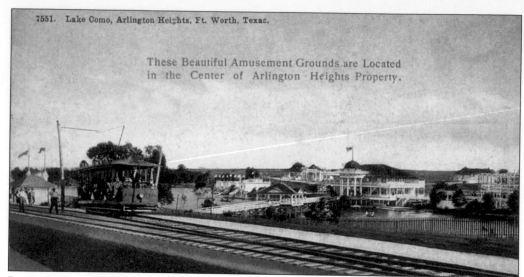

These Beautiful Amusement Grounds are Located in the Center of Arlington Heights Property.

LAKE COMO, ARLINGTON HEIGHTS. As Fort Worth grew following the arrival of Swift and Armour and the expansion of the Stockyards, recreational opportunities also expanded. Lake Como, on the city's west side, was created in the 1890s as part of the troubled early development of Arlington Heights. The park was enlarged after the turn of the century to include a dance pavilion, boat rentals, a boardwalk, and roller coaster, all accessible by streetcar from downtown. The park remained a popular spot until the end of World War I, when Lake Worth became the new recreational center. (Unknown Publisher, *c.* 1907.)

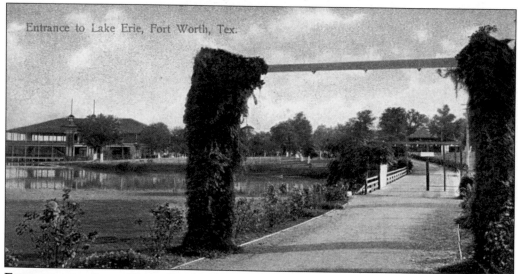

Entrance to Lake Erie, Fort Worth, Tex.

ENTRANCE TO LAKE ERIE. On the far east side of the city, the Northern Texas Traction Company, owner of the Interurban Streetcar line between Fort Worth, Dallas, and other cities in the area, built a power plant and lake near the Handley stop to supply energy to the line. To encourage riders and promote development, the company constructed a pavilion and picnic grounds complete with boat rentals, a bandstand, and several acres of walking paths. One highlight of the park was the boat slide that allowed visitors to ride boats down a short hill into the lake. Lake Erie and the amusement park were submerged under the waters of Lake Arlington, impounded in 1957. (International Post Card Co., *c.* 1910.)

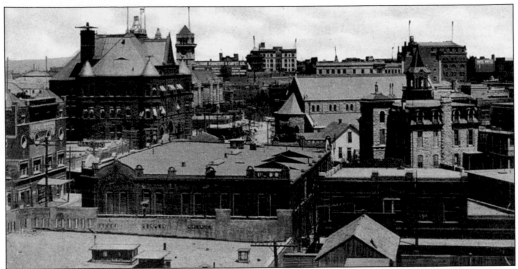

BIRD'S-EYE VIEW. The skyline of Fort Worth was beginning to reflect the rapid growth of the city at the turn of the 20th century. Looking north across the intersection of Jennings and Thirteenth Streets, at far left, with the round windows, is the original Majestic Theatre, built in 1901. The sandstone Federal Building, with the city hall in the background, sits across the street from Saint Patrick Cathedral and St. Ignatius Academy. The new Fort Worth National Bank Building rises in the center after opening at its new location at Fifth and Main Streets in 1904. (Curt Teich, *c.* 1908.)

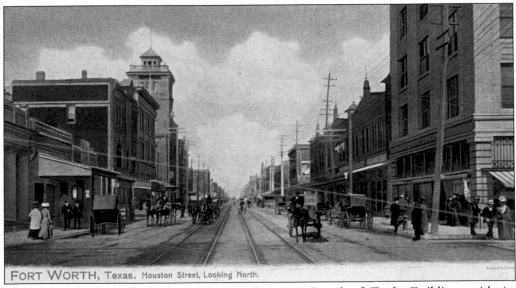

FORT WORTH, Texas. Houston Street, Looking North.

HOUSTON STREET, LOOKING NORTH. The 1889 Board of Trade Building, with its observation deck, towers over the street at the intersection of Houston and Seventh Streets, while buggies and bicyclists negotiate the double streetcar tracks along Houston Street about 1905. The first streetcars began running in 1876 pulled by mules along the length of Main Street. Services expanded with the growing town, with most of the competing companies eventually electrified and consolidated under the Northern Texas Traction Company. (Raphael Tuck & Sons, *c.* 1905.)

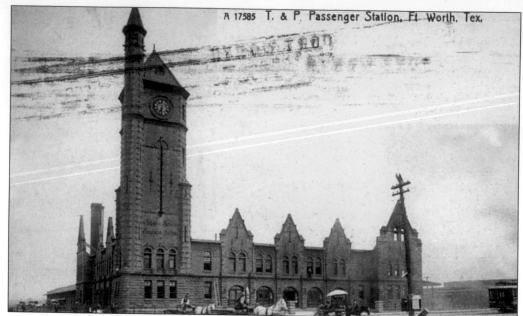

T&P PASSENGER STATION. In July 1876 the Texas and Pacific railroad was the first line to reach Fort Worth after years of delay. The company built this magnificent passenger station in 1900 at the intersection of Front Street (now Lancaster Avenue) and Main Street. Fire swept through the building in December 1904, destroying most of the interior. This image, taken shortly after the fire, shows the station with the roof gone and the walls braced for the pending rebuilding. The station was demolished in 1931 following the construction of a new Art Deco terminal in 1931. (Rotograph Co., *c.* 1904.)

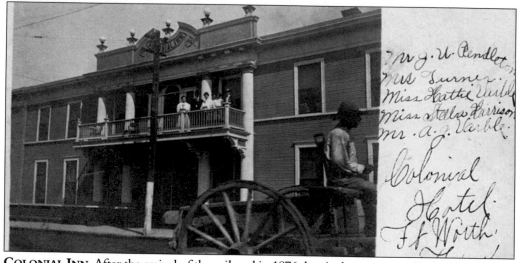

COLONIAL INN. After the arrival of the railroad in 1876 the city began to rapidly develop the area near the tracks and passenger facilities at the south end of town. The Colonial Inn was one of the numerous hotels built to accommodate the growing numbers of passengers and visitors and, by 1909, was managed by William P. Varble. Located at 304 East Fifteenth Street, between Calhoun and Jones, the rooming house had a barbershop and restaurant available to guests, three of whom posed for a photographer along with Varble's children. (Artura Realphoto, *c.* 1909.)

FLAT IRON BUILDING. Built in 1907 by Dr. Bacon Saunders, dean of the Fort Worth Medical College, the Flatiron Building is one of the most recognizable landmarks in Fort Worth and a rare survivor of the early "skyscrapers" that appeared on the skyline in the first decade of the 20th century. Designed by the local firm of Sanguinet and Staats, the building mirrored on a smaller scale the flatiron buildings Dr. Saunders may have seen in Chicago and New York. Incorporated into the design were carved panther heads commemorating Fort Worth's nickname of "Panther City." The legend of the sleeping panther dated to an 1873 economic slump when it was reported that things were so quiet in Fort Worth that a panther was seen sleeping in the middle of Main Street. Rather than finding the story insulting, Fort Worth embraced the panther as the city's mascot, even including it on the police badges. Listed in the National Register of Historic Places, the Flatiron underwent extensive renovations before reopening in 2003. (Unknown Publisher, *c.* 1908.)

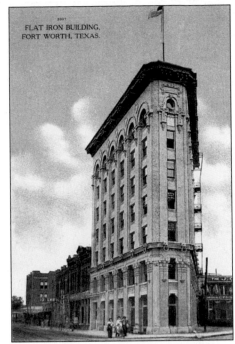

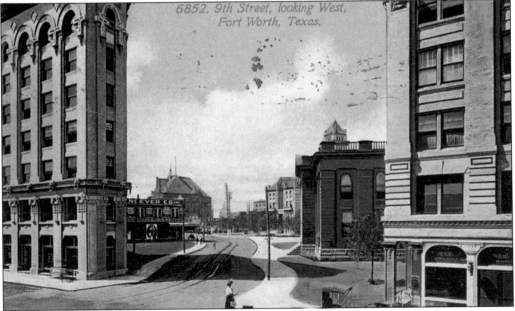

NINTH STREET. The new Flatiron Building sits at left in this view looking down Ninth Street past the Carnegie Library with city hall and the federal building in the distance. Behind the Flatiron Building, the J.J. Langever Company supplied most of the growing city's signs and banners, including the elaborate decorations for the T&P Passenger Station when, in 1905, Theodore Roosevelt became the first sitting President to visit Fort Worth. The building in the foreground at right was the Western National Bank, built in 1906, and today converted into downtown apartments. (Unknown Publisher, *c.* 1909.)

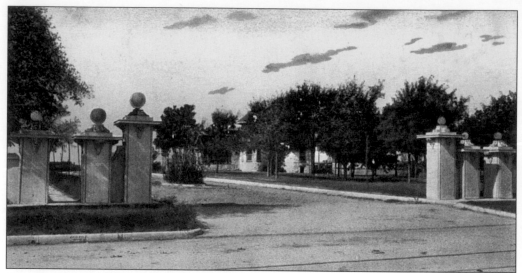

CHASE COURT. The expanding population of Fort Worth pushed south of the railroad tracks as new subdivisions and a growing streetcar system attracted residents. One of the first planned developments in the city was Chase Court, a one block residential area at South Hemphill and West Allen Streets. Named after E.E. Chase, a banker and one of the early street railway promoters whose home originally sat on the site, the neighborhood is enclosed by a low wall and elaborate entrance gates, and still retains several of its early 20th century homes. (Elite Post Card Co., *c.* 1908.)

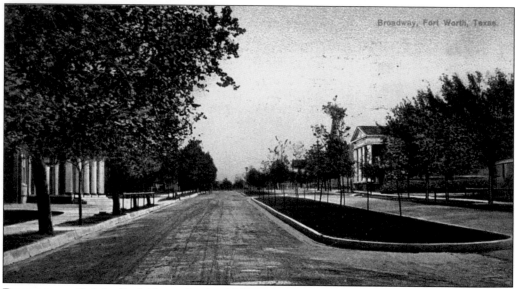

BROADWAY. Originally laid out in the 1880s, Broadway Avenue remains one of the city's widest streets, although it is much changed today from the peaceful and well-manicured divided residential avenue shown in this image from about 1908. At left, the columned porch of Broadway Presbyterian Church looks across the street to the 1906 sanctuary of Broadway Baptist Church. Scattered along the street were the church parsonages and other homes. The congregations had been neighbors since the mid 1880s and would both see their sanctuaries destroyed by fire in 1909. (Elite Post Card Co., *c.* 1908.)

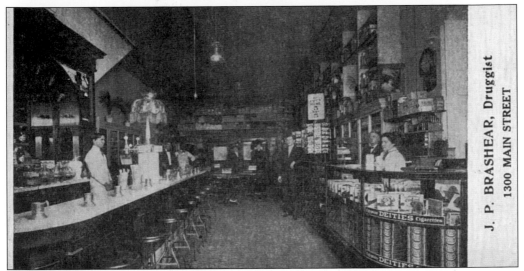

J.P. BRASHEAR, DRUGGIST. Located at 1300 Main Street, under the present site of the Fort Worth Convention Center, this drug store offered a typical variety of services to residents and visitors. Brashear had operated with partner Frank Hill since 1891, but shortly before this image was taken he took over the business to operate on his own. At left is the soda fountain with an attendant stiffly posing for the formal store portrait. On the opposite side of the store, the tobacco display advertises "Deities Egyptian Cigarettes," and in the middle of the counter on the right is a carousel of postcards announcing "All City Views 3 for 3 Cents." (Unknown Publisher, c. 1908.)

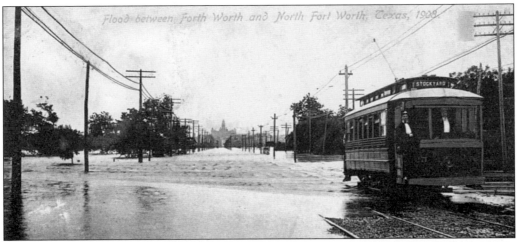

FLOOD, 1908. The Trinity River alternated between running dry and running very high. Floods plagued the city until the Army Corps of Engineers completed major flood control projects in the 1950s. This image shows a streetcar at the water's edge during the 1908 flood with the Tarrant County Courthouse rising in the background. At the time of the flood North Fort Worth, which included the rich Stockyards area, was a separately incorporated city. It would be annexed the following year, leading the Stockyards businesses to incorporate Niles City to protect the assets of the area from Fort Worth taxation. For a time, the one-and-a-half-square-mile "city" was "The Richest Little Town in the World," with property values exceeding $30 million by 1923 when Fort Worth finally annexed the area. (Haddaway Drug Company, North Fort Worth, Texas, 1908.)

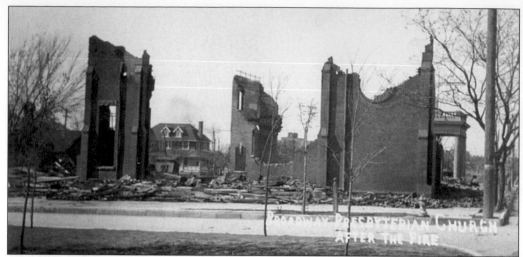

Broadway Presbyterian Church after the Fire. On the windy Saturday afternoon of April 3, 1909 two boys experimenting with tobacco accidentally started a fire in a barn on Terrell Avenue on the city's south side. Before the day was out the worst fire in Fort Worth history destroyed more than 300 buildings and caused one death. Among the losses were the sanctuaries of Broadway Presbyterian and Broadway Baptist, a private hospital, scores of homes, and several buildings belonging to the Texas and Pacific Railroad. The strain that fighting the fire put on the city's artesian water system led to plans for a more stable water supply and the eventual creation of Lake Worth. (AZO Realphoto, 1909.)

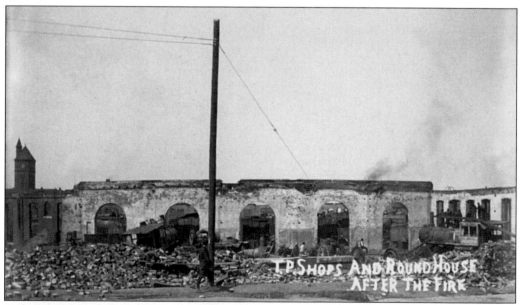

T.P. Shops and Roundhouse after the Fire. As the fire progressed toward downtown officials worried that the uncontrollable blaze might reach the business district. Fortunately the railroad compound—and relatively open space—lay between the fire and the rest of the city. The fire burned itself out after consuming the T&P shops and roundhouse and after causing nearly $1 million worth of damage across its path. Help had been on its way from Dallas by special train when the Dallas crews were called back to fight a large fire at home. (AZO Realphoto, 1909.)

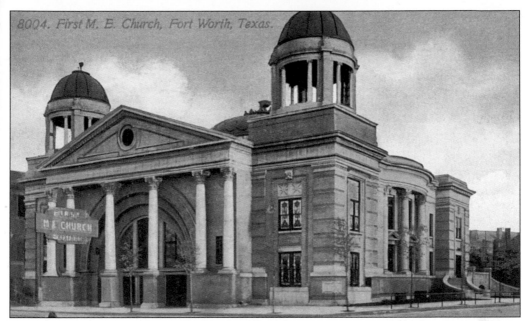

8004. First M. E. Church, Fort Worth, Texas.

FIRST M.E. CHURCH. The Methodists held their first services in Fort Worth in 1872 and later built a frame church at Fourth and Jones Streets in 1874. That first building was replaced on the same site by a larger church in 1887, but by 1906 the congregation had outgrown the church and began construction of a new sanctuary at the corner of Seventh and Taylor Streets. Opening on March 8, 1908 the new building would be home to the First Methodist congregation until continued growth, and the merger with St. Paul Methodist Episcopal Church, led to the construction of a new church in 1931. (Acmegraph, *c.* 1909.)

FIRST BAPTIST CHURCH. Although the Baptists had organized in Fort Worth as early as 1867, the First Baptist congregation traces its roots to 1873. In 1886, the church built the 1,100 seat gothic sanctuary shown here at Third and Taylor streets. It would be the arrival in 1909 of a young preacher named J. Frank Norris that would vault the church to the center of a whirlwind of reform and reprisal. Norris launched from his pulpit an attack on Hell's Half Acre and on the city's prominent citizens, among them members of his church, who owned property in the Acre. The reform campaign would eventually succeed, but among the casualties of the fight was the church building itself, burned by an arsonist in 1912. Norris was accused of the crime, but acquitted. (International Post Card Co., *c.* 1909.)

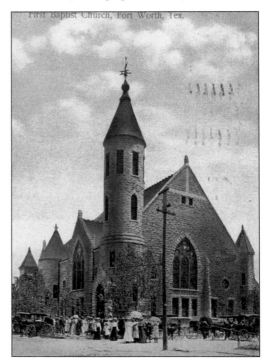

First Baptist Church, Fort Worth, Tex.

35

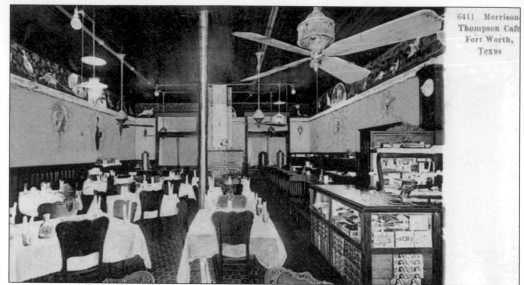

MORRISON-THOMPSON CAFÉ. Typical of the small cafes and restaurants scattered around the business district, Morrison-Thompson Café offered plain meals at low cost. Located at 103–105 West Sixth Street, owners William H. Morrison and Quinne Thompson decorated their café with paintings of wild fowl above the picture rail and offered their customers the obligatory cigars from a display case at the checkout stand. The sender of the postcard asked his friend in Minneapolis "Did you ever eat here old girl?" (Adolphe Selige Pub. Co., *c.* 1908.)

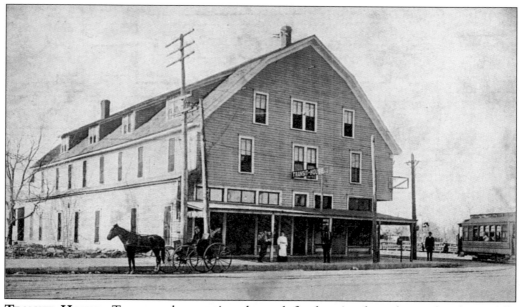

TRANSIT HOUSE. To meet the pressing demand for housing brought on by the rapidly expanding Stockyards operations, Mr. and Mrs. W.F. Stewart opened the Transit House in North Fort Worth about 1907 to provide room and board for packing plant and yard workers. Mrs. Stewart ran the boarding house at 2425 North Main Street while her husband was a partner in the Stockyards firm of Barry, Stewart and Dearing, dealers in real estate, farms, ranches, livestock, and insurance. His office was at 117 West Exchange Avenue. (Unknown Publisher, *c.* 1907.)

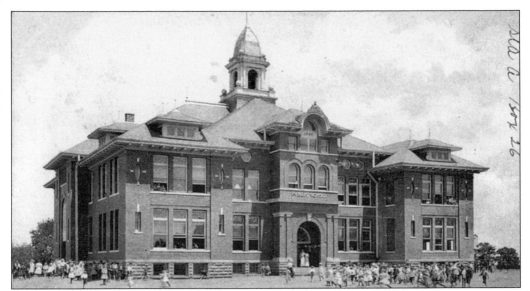

NORTH FORT WORTH PUBLIC SCHOOL. Built in 1905, when North Fort Worth was a separate city, this was the third school to serve the area originally called Marine, after the creek that runs through the Stockyards. Taken over by the Fort Worth school system after annexation in 1909, the building later housed an elementary school and was renamed for Merida G. Ellis, a prominent North Fort Worth landowner and businessman. The school closed in 1968 and remained vacant until it was destroyed by fire in 1986. (L.A. Barnes, 1908.)

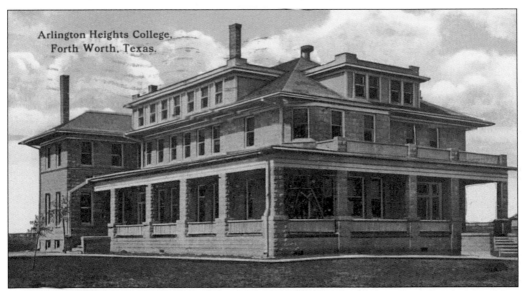

ARLINGTON HEIGHTS COLLEGE. Run by Rev. Edward Thomson, the Arlington Heights College for Young Ladies was located two blocks east of Lake Como and provided a sheltered environment for young women to learn teaching skills and home economics. Like so many private educational operations, the college lasted only a few years. Perhaps to the relief of Mrs. Ella Thomson, who served as dean, the school had closed by the time World War I led to the opening of Camp Bowie and the influx of thousands of young men who might have found the small campus irresistible. (S.H. Kress, *c.* 1909.)

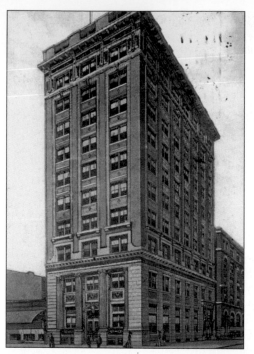

FIRST NATIONAL BANK. The roots of the First National Bank went back to 1870 when founder Capt. M.B. Loyd arrived in Fort Worth and established an exchange room to become the town's first banker. He incorporated the First National in 1877 and would remain its president until 1912. In 1909 Loyd hired the firm of Sanguinet and Staats to design a new building to be erected on the northeast corner of Seventh and Houston Streets, the new financial center of the city. Completed in 1910, the building has undergone extensive remodeling over the years, but still stands as a reminder of the strength of the old Fort Worth banking community. (Unknown Publisher, 1909.)

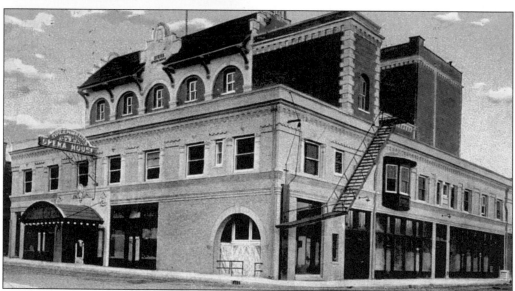

BYER'S OPERA HOUSE. The Greenwall Brothers replaced their aging 1883 Opera House at Third and Rusk Streets with a bigger modern theatre at Seventh and Rusk (now Commerce Street) with the backing of landowner and investor A.T. Byers. As vaudeville ended and movies took over, it would become the Palace Theatre, eventually demolished to make way for an office tower. In September 1908 a young stagehand named Barry Burke installed a light bulb over the stage door that was still burning 70 years later when *Ripley's Believe It or Not* joined the *Guinness Book of World Records* to chronicle "The Eternal Light." The light bulb still burns today in the Museum of the North Fort Worth Historical Society in the Stockyards. (Elite Post Card Co., *c.* 1909.)

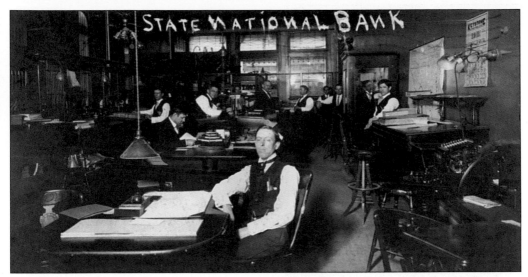

STATE NATIONAL BANK. This February 1909 image shows the interior of the State National Bank at Fourth and Main Streets. Established in 1884 it was the fifth bank in Fort Worth to receive a national charter. By the time of this picture, W.B. Harrison served as president and Sumpter T. Bibb, a grain and coal dealer and investor in the bank, served as vice president. In 1913 the bank commissioned Sanguinett and Staats to design a new building to replace the one shown here. Shortly after its completion, and perhaps because of it, the bank closed its doors in 1914 and the new building was acquired by Burk Burnett, whose name the building still carries. (Reelphoto, Unknown Publisher, 1909.)

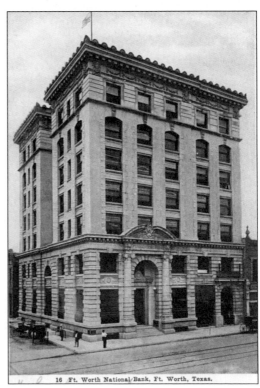

FT. WORTH NATIONAL BANK. In 1873 Thomas A. Tidball and John B. Wilson established the banking house of Tidball and Wilson. A year later they were joined by Maj. K.M. VanZandt who would serve as president until 1930, long after the bank reorganized in 1884 as the Fort Worth National Bank. In 1904 the bank built a new six- story skyscraper on the northwest corner of Fifth and Main Streets that it would occupy until it merged with the Farmers and Mechanics Bank in 1927 and relocated to Seventh and Main. The 1904 building was demolished to make way for the Art Deco Sinclair Building in 1929. (Frank S. Thayer, 1907.)

16 Ft. Worth National Bank, Ft. Worth, Texas.

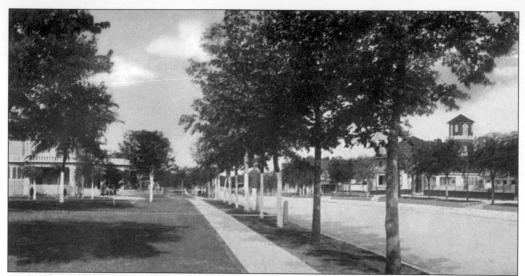

PENNSYLVANIA AVENUE. By the time this view, looking east on Pennsylvania Avenue, was taken about 1909, the street was well established as a "silk stocking row," lined with houses of Fort Worth's wealthy. The low wall on the right encloses the grounds of the Wharton mansion, also called Thistle Hill, today a house museum showcasing the remarkable stories of the Waggoner, Wharton, and Scott families who lived there. The tall structure at right was the water tower of the Breckenridge Walker house. On the left two other palatial homes flanked the intersection of Pennsylvania and Summit Avenues. (Unknown Publisher, *c.* 1909.)

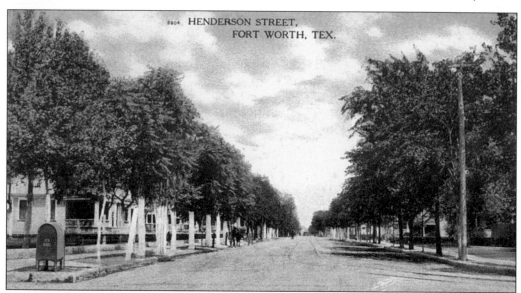

HENDERSON STREET. The streetcar from downtown followed Henderson Street out to this jog in the road at the intersection with Pennsylvania Avenue. The Fort Worth University campus stood a block down on the left, while the recently opened Fairmount Addition began to grow farther to the south. Today the Fairmount neighborhood is listed in the National Register of Historic Places, and the intersection in this image is a gateway to the redeveloping medical, commercial, and residential district called Fort Worth South. Nothing pictured remains today except the familiar design of the mailbox on the corner. (Curt Teich, *c.* 1909.)

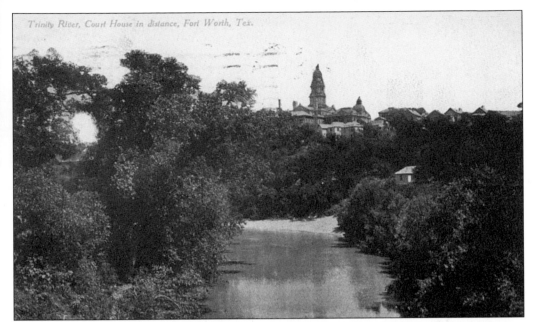

TRINITY RIVER. This peaceful scene looking down the river from just below the confluence of the Clear and West Forks of the Trinity belies the danger of frequent flooding. The courthouse rises majestically over the river on the site first occupied by the military outpost in 1849. Just below the courthouse can be seen the rooftops of the small community called La Corte, one of the city's early Hispanic neighborhoods. A few foundations remain along the bluff to remind us of the pioneer families who lived there. (Fred Harvey, *c.* 1908.)

A PRETTY SPOT. With a classically optimistic caption, this image shows one of the many creeks flowing into the Trinity River. This may picture Sycamore Creek, on the city's east side, where the Interurban Line between Fort Worth and Dallas crossed over. (S.H. Kress, *c.* 1908.)

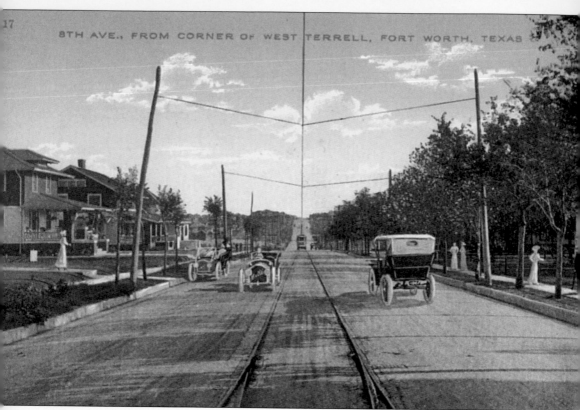

8TH AVE., FROM CORNER OF WEST TERRELL, FORT WORTH, TEXAS

EIGHTH AVENUE. By 1910 Fort Worth's population was close to 75,000, having nearly tripled since 1900. Automobiles were beginning to replace horse and mules, and the city began to expand in all directions. This view looks south on Eighth Avenue from West Terrell, near today's Cook Children's Medical Center, down the street car line that extended south as far as Jessamine. West Terrell had been the southern boundary of the city limits when Fort Worth was incorporated in 1873. (S.H. Kress, *c.* 1910.)

Three
1910–1920

2723 BRYAN AVENUE. Newly built when the picture was taken in 1909, this house on Bryan Avenue was situated far on the southern outskirts of town near the Missouri, Kansas, and Texas railroad tracks, just northeast of today's intersection of Hemphill and Berry Streets. Dressed in their finest for a formal photograph, the group even included the family dog in the special occasion. (Unknown Publisher, 1909.)

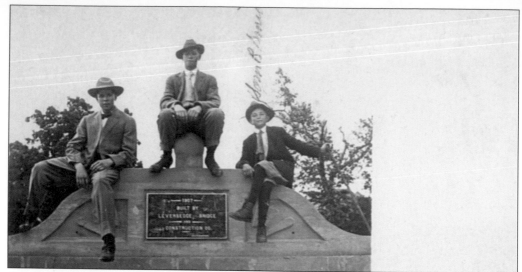

GROUP PORTRAIT. The caption of this image says "Polytechnic College Freshmen 1910." Judging from the clothes and youthful appearance of the three, they may have been members of the college's sub-freshman class, a preparatory program open to younger students. They are sitting on the centerpiece of the Sycamore Creek Bridge, built in 1907 and an easy walk from the college campus. It was in Sycamore Park that Baseball Hall of Famer Tris Speaker, then a student at Polytechnic College, would catch the Interurban train to Cleburne to play his first professional games. The old Interurban bridge still crosses the Creek in the park today. (Unknown Publisher, 1910.)

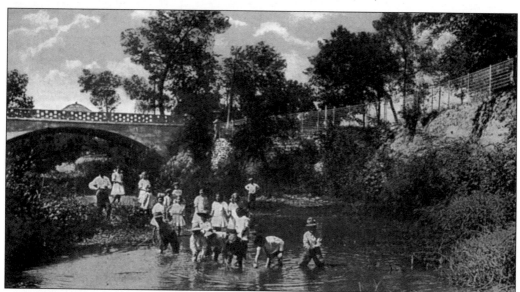

SYCAMORE PARK. Looking up from the creek to the bridge seen in the last image, this scene shows a group of children playing in the creek, perhaps catching minnows or tadpoles. Sycamore Park had been laid out in 1909 as part of a master parks plan for the city and was the primary recreational spot for residents of the east side. It remains one of the city's prettiest parks and serves as an important amenity as the neighborhoods around it redevelop. (Seawall Specialty Co., *c.* 1910.)

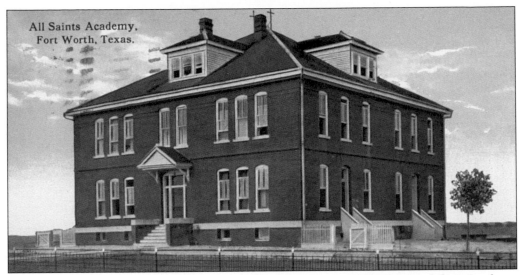

All Saints Academy,
Fort Worth, Texas.

ALL SAINTS ACADEMY. The Sisters of Charity of the Incarnate Word opened their Academy about 1907 at 2115 Belle in North Fort Worth. Responding to the needs of the hundreds of new families relocating to Fort Worth to work in the packing plants and stockyards, the Sisters opened a boarding and day school for boys and girls on a site with a commanding view over the Trinity River valley above the present Jacksboro Highway. The Academy was restricted to girls by 1914 and continued to operate until about 1927, when it closed. (S.H. Kress Co., *c.* 1913.)

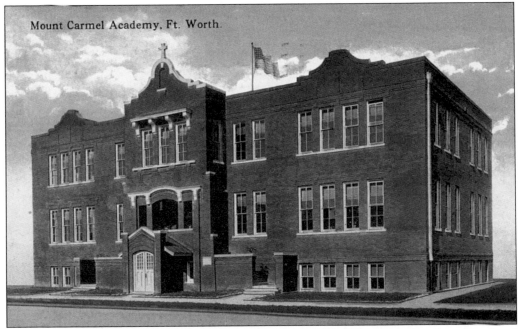

Mount Carmel Academy, Ft. Worth.

MOUNT CARMEL ACADEMY. The Sisters of Charity continued to respond to the educational needs of the North Fort Worth community by opening Our Lady of Mount Carmel Academy in 1911 on Clinton Avenue. In 1913 they built the new school facility shown here at 2006 Houston Street. The school changed its name to All Saints Parochial School in 1957 and today serves area elementary students in the old Academy building. (Frey Wholesale Postcard Co., *c.* 1915.)

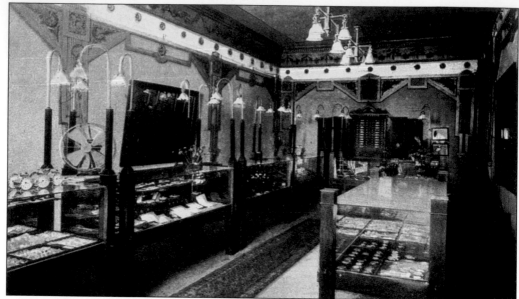

JEWELRY STORE OF L.P. DAVIS. Louis P. Davis operated his short-lived jewelry store from an upscale address at 713b Main Street from 1911 to 1914. Selling everything from fine watches to alarm clocks, the store may have been too expensive to operate profitably. Davis ended up conducting business from his home on Cherry Street before apparently leaving Fort Worth about 1916. (Unknown Publisher, *c.* 1912.)

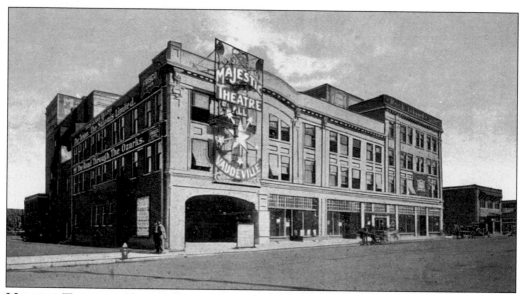

MAJESTIC THEATRE. The new Majestic Theatre at Tenth and Commerce opened to Fort Worth audiences in 1910 and quickly became the most popular stage in town. It joined the Princess and Imperial Theaters on Main Street to bring Vaudeville entertainment to Fort Worth while the new Greenwall's Opera House on Seventh Street hosted what was called at the time more "legitimate theatre." Majestic Theatre managers created a "great white way" by stringing white lights along Tenth Street from Main to direct audiences to the front door on Commerce. The building was demolished as part of the Convention Center project in the sixties. (S.H. Kress, *c.* 1910.)

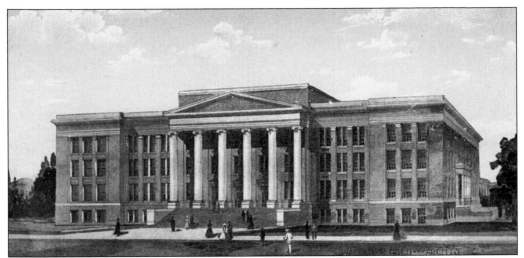

ADMINISTRATION BUILDING, TEXAS CHRISTIAN UNIVERSITY. Tracing its roots to a school founded in Fort Worth in 1869 by Addison and Randolph Clark, and renamed Add-Ran College in 1873 when it left the less than Christian atmosphere of a growing Hell's Half Acre, the University returned to Fort Worth in 1910. Located for a time in Thorp Springs, near Granbury, the school had moved to Waco in 1896 but lost its home in February 1910 following a fire that destroyed the main building. Several cities across the state competed for the opportunity to provide a new home, with Fort Worth winning the bid. Local architects Waller and Field were commissioned to design the new campus and presented renderings of the proposed construction, including the administration building shown here. (S.H. Kress, *c.* 1911.)

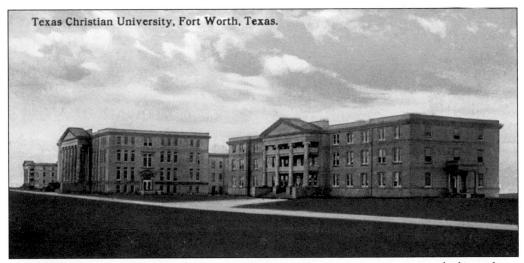

Texas Christian University, Fort Worth, Texas.

TEXAS CHRISTIAN UNIVERSITY. Housed in temporary quarters scattered throughout several buildings along Weatherford and Belknap Streets, TCU inaugurated its return to Fort Worth with an opening convocation for the 1910–1911 academic year in the city hall auditorium presided over by school founder Addison Clark, who, with his brother Randolph, had begun Add-Ran College in 1873. The University occupied its new campus in the fall of 1911. Fort Worth had provided 50 acres, $200,000 in cash, and the promise that streetcar lines and city utilities would be run to the site on the open prairie southwest of downtown. (S.H. Kress, *c.* 1911.)

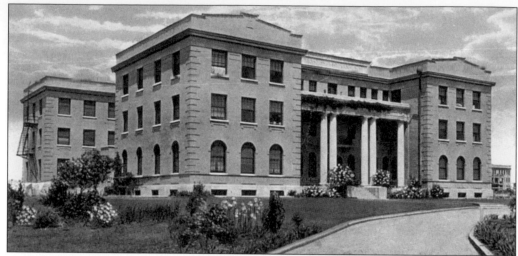

BAPTIST SEMINARY. The Southwestern Baptist Theological Seminary traces its roots to 1873 when Baylor graduate B.H. Carroll began offering classes in his Waco home. Carroll was instrumental in the establishment of Baylor's theological program, which began in 1905, became independent in 1907, and was looking for larger quarters and a new home by 1910. Fort Worth Baptist leaders and citizens offered 250 acres and $100,000 in cash to bring the school to town ready to begin classes in the fall of 1910. The early campus buildings were designed by architects Sanguinet and Staats, including the 1915 Women's Missionary Training School shown in this image. (S.H. Kress, *c.* 1915.)

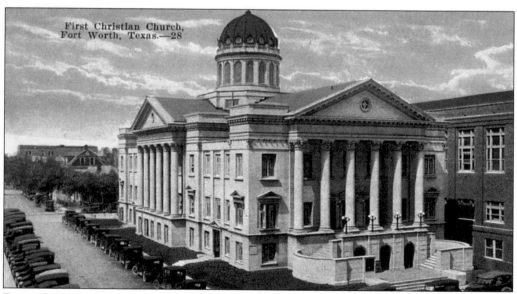

FIRST CHRISTIAN CHURCH. In 1855, just six years after the founding of Fort Worth, a small group of people gathered with Mrs. Florence Peak for Sunday school in her log home that had once served as an officers' quarters at the fort. At that early gathering First Christian Church became the first organized congregation in the city. Services were held at several locations until the 1914 construction of the present sanctuary, designed by local architects Van Slyke and Woodruff. Among the church's ministers was Rev. J.A. Clark, whose sons, Addison and Randolph, founded Add-Ran College, now TCU. (E.C. Kropp, *c.* 1920.)

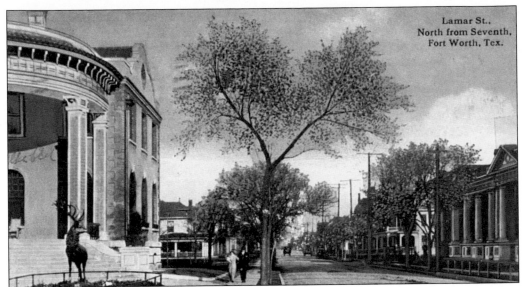

LAMAR STREET. Downtown was still a major residential area at the time of this image taken *c.* 1912. At left is the Elks' Club Building, constructed in 1910 by the Fort Worth Lodge Number 124 of the Benevolent and Protective Order of Elks, one of the largest fraternal organizations in town at the time. Lamar Street north of Seventh had been one of the city's early "silk stocking rows," with the homes of Fort Worth's wealthiest citizens sharing the street with three churches, including St. Paul's M.E. Church. (Frey Wholesale Postcard Co., *c.* 1912.)

YMCA. After an unsuccessful attempt to establish the YMCA in Fort Worth in 1877, the organization was revived in 1890 and, for a time, utilized the campus facilities of Polytechnic College, today's Texas Wesleyan University. Until Mrs. Winfield Scott was persuaded in 1923 to donate the site of her former home on Lamar Street, the organization was housed in the building pictured here, located at 914–918 Monroe at Texas Street. The facility offered its members and guests a gymnasium, reading and game rooms, bowling alleys, boxing and wrestling rooms, dormitory rooms, and a café. The YMCA became a center of activity for soldiers training in Fort Worth during the World War I years. (Frey Wholesale Postcard Co., *c.* 1915.)

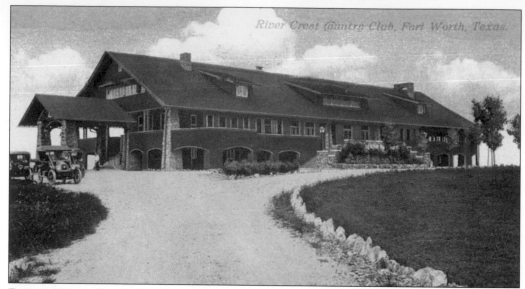

RIVER CREST COUNTRY CLUB. Organized April 13, 1911 by stockholders of the River Crest Company, the country club was the centerpiece of a 640 acre development that remains today one of Fort Worth's most exclusive residential sections. The club covered 160 acres with a premier golf course and, in 1922, the city's first outdoor swimming pool. Over the course of five remodeling efforts the original 1912 clubhouse, designed by Sanguinet and Staats and pictured here, lay buried beneath successive facades until a 1981 fire destroyed the building. (Octochrome, *c.* 1914.)

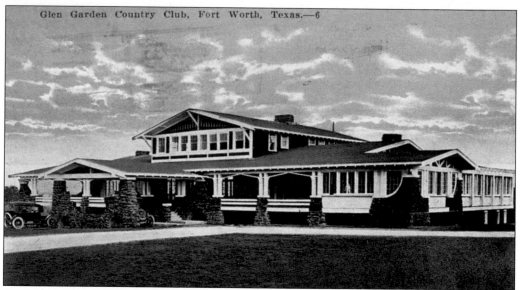

GLEN GARDEN COUNTRY CLUB. Following up on the success of River Crest and the growing enthusiasm for golf and tennis, Glen Garden Country Club was established in 1913 on the city's southeast side and promoted by L.D. and Horace Cobb, owners of the neighboring Cobb Brick Company. Long the home of city golf tournaments, Glen Garden was also the home course of Byron Nelson in his early playing days. The 1914 Craftsman style clubhouse shown in this image was demolished in 2001 to make way for a modern facility for the golf club. (S.H. Kress, *c.* 1915.)

THE STATE NATIONAL BANK. Organized in 1884 the State National Bank commissioned Sanguinet and Staats to design a new skyscraper for Fort Worth. Construction began in 1913 but by the time it was completed, the bank had closed its doors. Capt. Samuel Burk Burnett, cattleman and son-in law of First National Bank's founder M.B. Loyd, purchased the building in 1915, renaming the city's newest and tallest skyscraper the Burk Burnett Building. Restored in 1984 as part of the Sundance Square development, it remains one of Fort Worth's landmark structures and is listed in the National Register of Historic Places. (L.M. Mitchell & Co., *c.* 1914.)

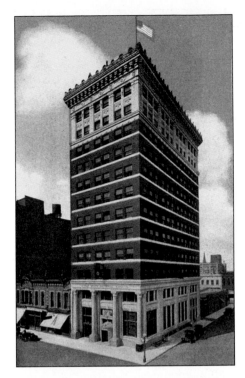

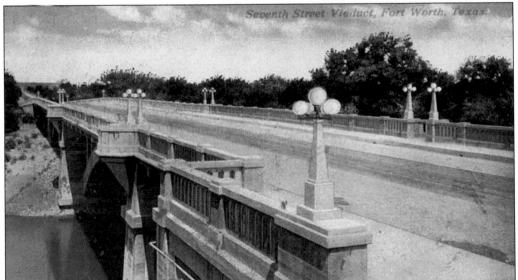

SEVENTH STREET VIADUCT. For most of the city's early years the only way across the Trinity River from downtown to the west was by the low water crossing near the present Seventh Street. An iron bridge was built across the river in the 1890s to accommodate the streetcar line heading out to the Arlington Heights development and Lake Como. As the city began to grow rapidly after the arrival of the packing plants, a newer bridge was built in 1910. Rebuilt when the river was rerouted in the 1930s, remnants of the old bridge shown here, including the arch over the original river channel, can still be seen under the east end of the structure as it passes over Forest Park Boulevard. (Octochrome, *c.* 1914.)

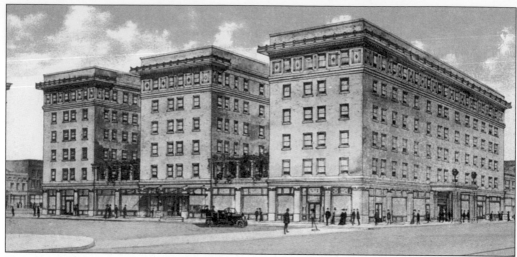

THE NEW DELAWARE FIRE PROOF HOTEL. Fort Worth's hotel corner at Fourth and Main, home of the El Paso, Pickwick, and Delaware since 1878, added a new name to the list in 1911 when the New Delaware, quickly renamed the Westbrook, opened its doors. Built by Benjamin Tillar, the hotel became a major hub of activity during the World War I years as it hosted Canadian and American pilots, Camp Bowie infantrymen, and oil operators hoping to strike it rich in the newly discovered West Texas fields. Its glory days long past, the hotel was demolished in 1973 to make way for the parking lot watched over by today's Chisholm Trail mural in Sundance Square. (S.H. Kress & Co., *c.* 1910.)

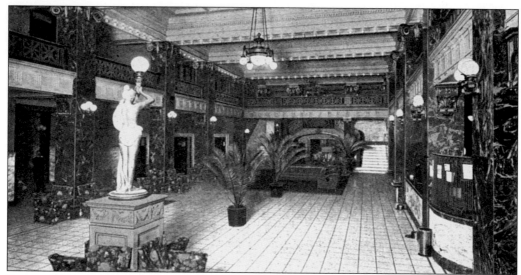

LOBBY, WESTBROOK HOTEL. No Fort Worth icon is more storied than the Golden Goddess, shown here watching over the lobby of the Westbrook Hotel from her perch of 62 years. During the oil-boom days of 1917–1918 operators, speculators, and all those hoping to get rich on West Texas oil created a legend by rubbing the Goddess's rear for good luck. When the hotel was demolished, the Goddess moved and spent almost 30 years watching over customers at the Old Spaghetti Warehouse in the Stockyards. When the restaurant closed, she was bought by the Petroleum Club of Fort Worth, restored and placed in a position of honor befitting her legendary status and unique role in the history of the oil industry. (Scawall Specialty Co., *c.* 1912.)

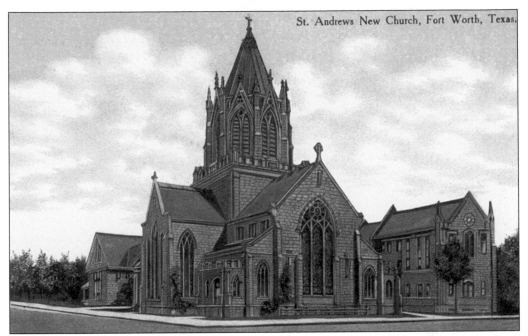

St. Andrews New Church. The first Episcopal congregation in Fort Worth dates to about 1875, when the bishop of the new Northern Texas diocese created the church with ten members. Starting services in a frame building at Fifth and Rusk (now Commerce) Streets, the congregation commissioned Sanguinet and Staats to design a new church at Lamar and Tenth Streets. Construction began in 1909 and was completed in 1912 after additional funds were raised. This image shows the original concept proposed by the architects before the final design was completed and built. (S.H. Kress & Co., *c.* 1910.)

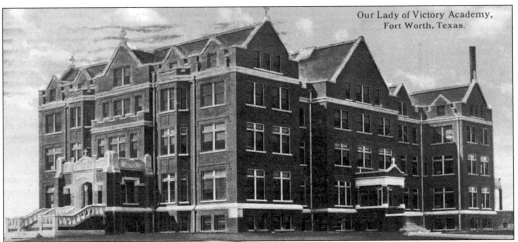

Our Lady of Victory Academy. Sanguinet and Staats also designed the magnificent Gothic Revival Our Lady of Victory Academy for the Sisters of Saint Mary of Namur in 1909. Opening in 1910 it operated as a day and boarding school until 1961, and ended its school functions in 1988. Scheduled for demolition, the building was purchased and rescued by Historic Landmarks, Inc. and converted into the Victory Arts Center, a residential and studio development. (Duke & Ayres Nickel Stores, *c.* 1911.)

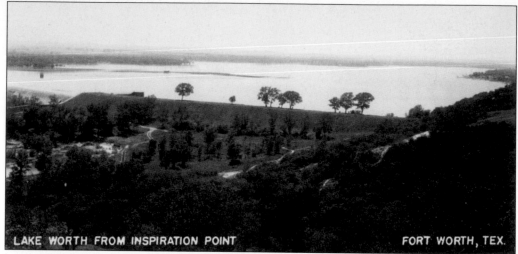

LAKE WORTH FROM INSPIRATION POINT FORT WORTH, TEX.

LAKE WORTH FROM INSPIRATION POINT. The disastrous southside fire in 1909, coupled with the city's realization that its system of artesian wells could not adequately supply the growing city's needs, prompted Fort Worth to move forward with plans to develop a reservoir on the Trinity River. Land acquisition and dam construction along the West Fork of the river began in 1911, with the first water topping the spillway in August, 1914. After considering several names for the new lake, including Minnetonka, Panther, and Tonkaway, city commissioners settled on Lake Worth. Even before the lake had filled locals began using it for recreation, frustrating officials who wanted to keep people out of the city's drinking water supply. Among the first to take advantage of the new lake was E.P. Haltom, son of the local jeweler, who launched a home-built sailboat in 1913. (Realphoto, 1917.)

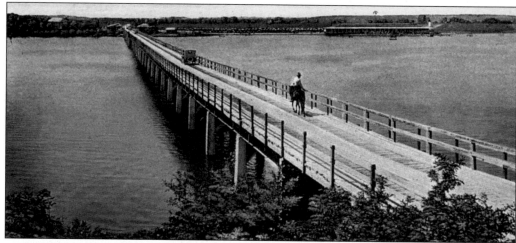

NINE MILE BRIDGE AT LAKE WORTH. The city limits were extended to Lake Worth in 1915 and tourists arrived by buses from the end of the streetcar line at Rosen Heights, north of the Stockyards. City officials proclaimed the lake and surrounding park, at 9,214 acres, as the largest municipal park in the world. The city began the first leg of the Meandering Road around the lake in 1916 and that year completed a bond program to fund a new water main to the Holly water plant. The old wooden Nine Mile Bridge shown here became the gateway to the public beach and bathing pavilion on the west shore. The bridge was replaced with a modern concrete structure built north of the pavilion in 1928. (Seawall Specialty Co., *c.* 1917.)

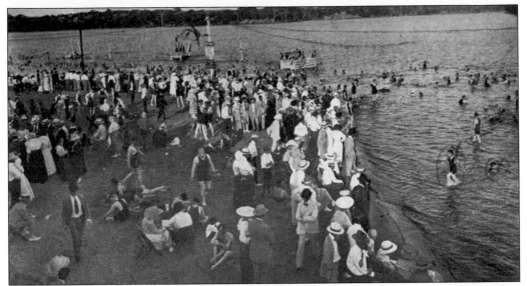

LAKE WORTH. By August 1917, just two months after the beach opened, more than 73,000 people had visited the park, nearly the entire population of the city at the time. Boats were available for hire and the city soon began issuing lakeside leases for fishing camps and weekend cottages. Local organizations and companies developed recreation areas, including Swift, Armour, First Baptist Church, and the Boy Scouts. As Camp Bowie was preparing to open to train American soldiers for World War I, the lake was approved by the army as a suitable recreational venue. In this image the beach is crowded with swimmers in their wool bathing suits being watched by onlookers in suits and dresses. Changing rooms and refreshments were available in the pavilion, just down the beach to the left. (Bryant Studio, *c.* 1917.)

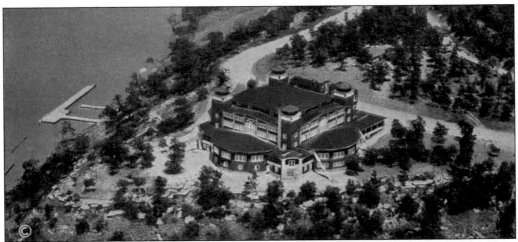

LAKE WORTH AND MOSQUE. None of the recreational facilities developed along the shore of the lake could compare to the Masonic Mosque, opened with great fanfare on July 4, 1919. Built by the local Masonic Lodges, the Mosque boasted the largest dance floor in the Southwest, accommodating 1,000 couples. From its commanding site on top of Reynolds Point, renamed Mosque Point, the building, with its seven-story minarets, could be seen for miles. First Methodist Church acquired the building from the Masons, renaming it Epworth Center and using it for a short time before it was destroyed by fire in January 1927. (E.C. Kropp Co., *c.* 1920.)

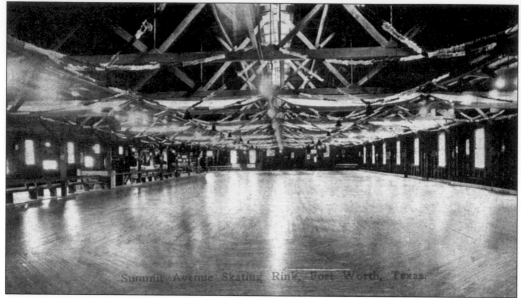

SUMMIT AVENUE SKATING RINK. Located at 1502 Jackson, later renamed Tenth Street, at the intersection with Summit Avenue, the skating rink was built about 1910 to accommodate the growing national fad of roller-skating. The large pavilion shared space with the Hartshorn Brothers Furniture Store and sat across the street from Rotary Park. The facility hosted major events and conventions, including a meeting of the Texas and Southwestern Cattle Raisers Association, before closing in 1913. (Unknown Publisher, *c.* 1912.)

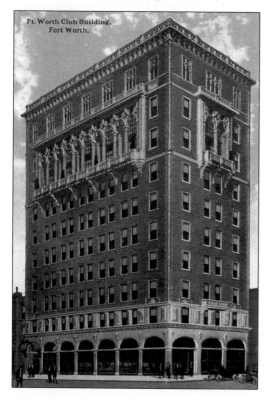

FORT WORTH CLUB BUILDING. Chartered in 1885 as the Commercial Club, the Fort Worth Club was started by a group of business leaders interested in creating a social club that would also focus on the city's expanding prosperity. Among the organizers were Maj. K.M. Van Zandt and Marshall Sanguinet, a young architect just beginning to make his mark. The club built a three-story building at Sixth and Main Streets that would serve as its headquarters from 1887 to 1915. This image shows the 1916 replacement building before major modifications scaled the design back to six stories. The club moved into its new home in May 1916, remaining there until it built a new club building in 1926 at Seventh and Throckmorton. The historic 1916 structure was renovated in 2001 into the upscale Ashton Hotel. (Frey Wholesale Postcard Co., *c.* 1915.)

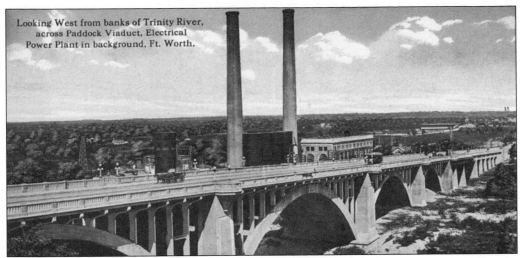

Looking West from banks of Trinity River, across Paddock Viaduct, Electrical Power Plant in background, Ft. Worth.

PADDOCK VIADUCT. To accommodate the rapidly growing area north of the Trinity after the arrival of the packing plants and expansion of the stockyards, the old iron bridge over the river below the courthouse was replaced in 1914 by a new concrete viaduct, named in honor of B.B. Paddock, publisher, state legislator, mayor, and perhaps the city's greatest promoter. The first reinforced concrete arched bridge built in the country, it is listed on the National Register of Historic Places, and is a Texas Historic Civil Engineering Landmark. Just west of the bridge is the 1912 generating plant of the Fort Worth Power and Light Company, forerunner of today's TXU Energy Co. (Frey Wholesale Postcard Co., *c.* 1915.)

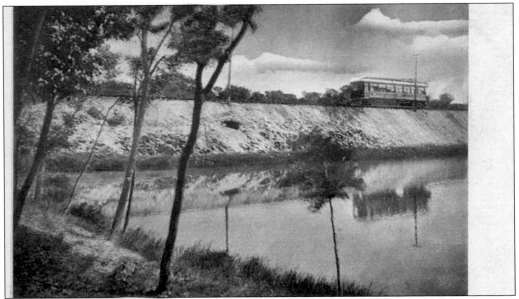

SCENE ON INTERURBAN. The Northern Texas Traction Company began intercity rail service between Fort Worth and Dallas and Fort Worth and Cleburne in 1902, eventually adding bus service beginning with shuttles from Rosen Heights to Lake Worth in 1915. This early image shows one of the company's "Red Limiteds" moving down the tracks, perhaps by Tandy Lake along the present East Lancaster Avenue or nearing the entrance to Lake Erie. The last Interurban made its run on Christmas Eve, 1934. (Unknown Publisher, *c.* 1905.)

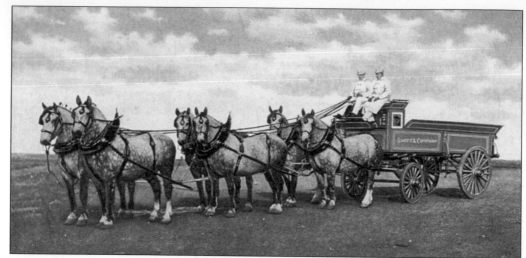

SWIFT & COMPANY'S PRIZE SIX-HORSE TEAM. Among the many attractions of the annual Feeders' and Breeders' show were the Horse Show activities. Beginning in 1908 the Horse Show grew each year to include cutting horse events, jumping exhibitions, and driving competitions. A regular winner in competition, the "Swift Six" impressed audiences and judges with the skills demonstrated by driver and team. Armour and Swift competed fiercely for top honors each year. This image shows the matched gray Percherons at the show in 1917, the year the annual event would change its name to the Southwestern Exposition and Fat Stock Show, a name it would carry for more than 50 years. (Unknown Publisher, 1917.)

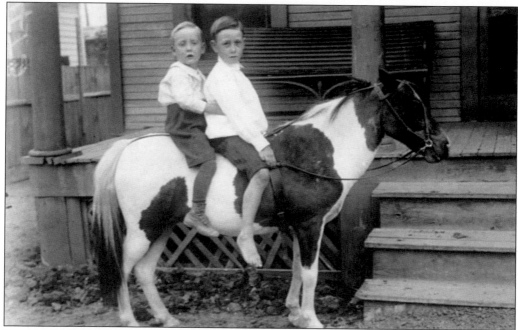

BOYS ON A PONY. Fort Worth still relied heavily on horses for transportation long after the arrival of the automobile. The two boys in this image, taken in 1915, in front of a home on Humbolt Street on the city's east side, seem perfectly content astride their pony, a far cry from the show horses regularly arriving in Fort Worth, but a favorite companion nonetheless. (Realphoto, 1915.)

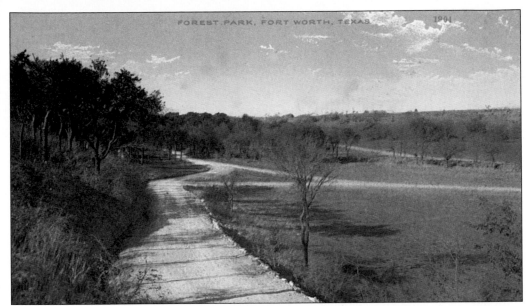

FOREST PARK. Fort Worth created its first park board in 1907. Two years later the board hired prolific landscape designer and urban planner George Kessler to develop a long-range park and boulevard plan for the city. Among his recommendations was the acquisition and development of land along the Trinity River leading to the development of Trinity and Forest Parks. This early image of the park shows a simple gravel road running through the open river bottoms, a quiet oasis in a growing city. (S.H. Kress & Co., *c.* 1911.)

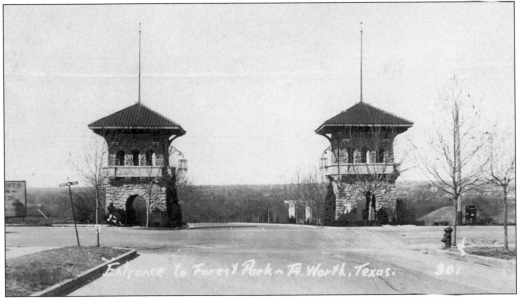

ENTRANCE TO FOREST PARK. The City of Fort Worth marked the entrance to Forest Park in 1917–1918 by erecting two large rubble-stone gates, designed by local architect John Pollard and built by William Bryce's construction company. Restored by the Berkeley Neighborhood Association in 1980, the magnificent gates still welcome visitors to the park and to the Fort Worth Zoo, founded in 1909. (Realphoto, *c.* 1920.)

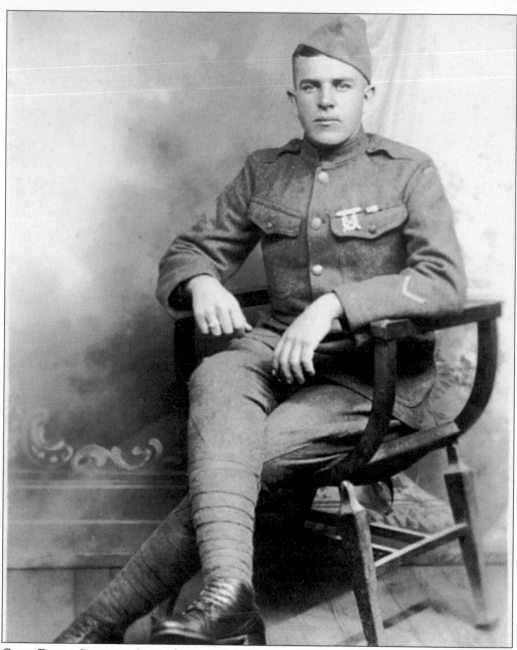

CAMP BOWIE SOLDIER. Soon after President Woodrow Wilson signed the Joint War Resolution on April 6, 1917 committing the United States to what would become World War I, the army began the work of establishing training camps for recruits. Fort Worth offered the government 1,400 acres on the city's west side, much of which had been part of the 19th century Arlington Heights development. The city also committed an additional 750 acres for a rifle range, 125 acres for trench training, utilities, a two-lane road, streetcar access, and a rail spur. Construction began in July 1917. By the time the camp, named for Texas revolutionary hero Jim Bowie, closed in 1919, more than 100,000 men of the 36th Division from Texas and Oklahoma, including this unknown soldier, had trained in Fort Worth before heading off to fight. (Realphoto, c. 1918.)

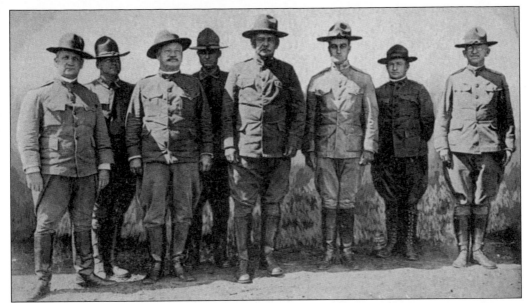

MAJOR GENERAL ST. JOHN GREBLE AND STAFF. The construction and operation of Camp Bowie was under the capable leadership of Edwin St. John Greble, here shown fourth from the right, a graduate of West Point and veteran of the Spanish-American War and Mexican border conflicts. While organizing the Texas and Oklahoma National Guards into the 36th Division, he was able to maintain strong and cordial ties to the Fort Worth community at a time that thousands of soldiers converged on the city. Local residents responded by providing a variety of entertainment activities at locations such as Lakes Como and Worth, the Westbrook Hotel and the camp YMCA. (Albertype Co., *c.* 1917.)

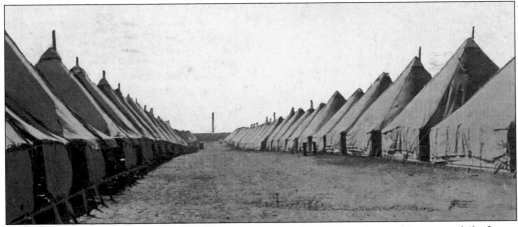

TENT STREET, CAMP BOWIE. The soldiers of Camp Bowie were housed in tents while frame officer's quarters were built along what is now Hillcrest Road, not far from the country club at River Crest. The base hospital covered 60 acres with over 70 buildings accommodating up to 1,000 patients, an important service during an outbreak of pneumonia in 1917 and the great flu epidemic of 1918 that killed more than 500,000 Americans and 22,000,000 people worldwide. Following their training the soldiers of the 36th Division departed in July 1918 for the front in France where they would participate in some of the most difficult fighting of the war during the Meuse-Argonne campaign. (A.M. Simon, *c.* 1917.)

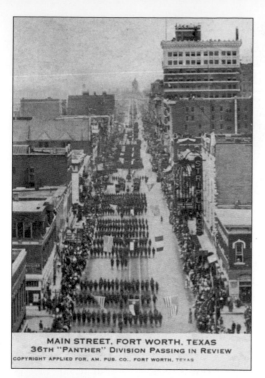

MAIN STREET, FORT WORTH, TEXAS
36TH "PANTHER" DIVISION PASSING IN REVIEW
COPYRIGHT APPLIED FOR, AM. PUB. CO., FORT WORTH, TEXAS

36TH "PANTHER" DIVISION PASSING IN REVIEW. Before the troops left Fort Worth for the war in Europe, the soldiers of Camp Bowie paraded for the people of Fort Worth who had provided so much support during the training period. On April 11, 1918 a crowd of more than 200,000 lined Main and Houston Streets to watch the "Pass in Review" as infantry, cavalry, and artillery units marched through downtown. The entire population of Fort Worth at the time was just over 100,000. This image, taken from the Tarrant County Courthouse, looks south on Main Street past the 14-story Burk Burnett Building, then the tallest building in town, toward the tower of the Texas and Pacific passenger Station seventeen blocks away. (American Publishing Co., 1918.)

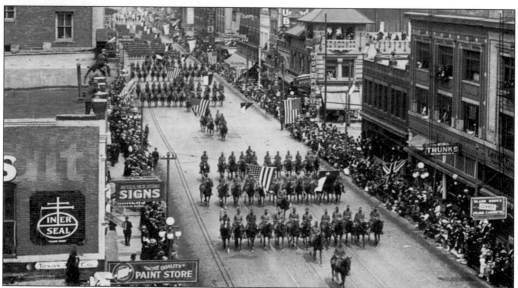

PASS IN REVIEW. Marching north on Main Street before turning to come back down Houston Street, the troops of the 36th Division passed under Texas and U.S. flags strung across the street. In the lower right of this image is a British flag, recognizing the many British and Canadian Flyers who had also trained in Fort Worth in preparation for the War. Among the Royal Flying Corps instructors was Capt. Vernon Castle, who, with his wife Irene, was one of the most famous dancers in the world before the war. Castle was killed in Fort Worth when his plane crashed after he avoided a collision with an American cadet at Carruthers Field in Benbrook. (Realphoto, 1918.)

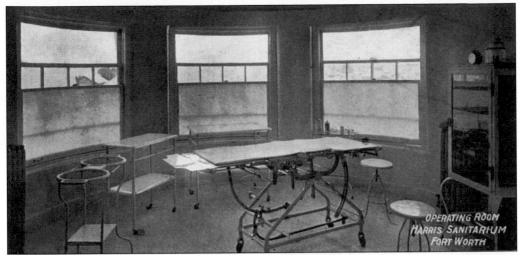

OPERATING ROOM, HARRIS SANITARIUM. Dr. Charles H. Harris opened his private hospital at Fifth and Rosedale in 1907 after moving to Fort Worth three years earlier from his country practice west of town. He later deeded the hospital to the Methodist Church on condition that the church enlarge and support it, leading to a merger with Methodist Hospital and the creation of today's Harris Methodist Hospital. In addition to his medical practice, Dr. Harris was also a breeder of Hereford cattle on his Harrisdale Farms, made famous for producing the champion bull, Prince Domino Return. With proceeds from the sale of the farm, Dr. Harris left a $1 million endowment to fund the Harris College of Nursing. The farm has long since been redeveloped into a suburban neighborhood, but the memorial to the doctor's prize bull still presides over a small plot of ground off of Las Vegas Trail north of Camp Bowie Boulevard. (Paxton and Evans, *c.* 1918.)

HOME OF WILLIAM M. McDONALD. Born the son of a former slave in 1866, William Madison McDonald was among the most successful African American business leaders in Texas during the early 20th century and may well have been the wealthiest in the Southwest. Shortly after his move to Fort Worth in 1912 he founded the Fraternal Bank and Trust at Ninth and Jones Streets, the centerpiece of a vibrant, though segregated, business community that spread across the East side of downtown. His bank was the primary depository for the Black Masonic Lodges in Texas, New Mexico, Arizona, Utah, and Nevada. It is said that he quietly lent money to some of the mainstream white-owned banks in Fort Worth to help them weather the lean days of the Depression. In addition to his Masonic leadership, McDonald was a major figure in the Black and Tan faction of the Texas Republican party, responsible for patronage and party agendas off and on for nearly 30 years. His imposing home on East Terrell Avenue was reportedly a copy of the home belonging to the man who had owned his father. It was demolished following McDonald's death in 1950. (M. Noble & Son, *c.* 1915.)

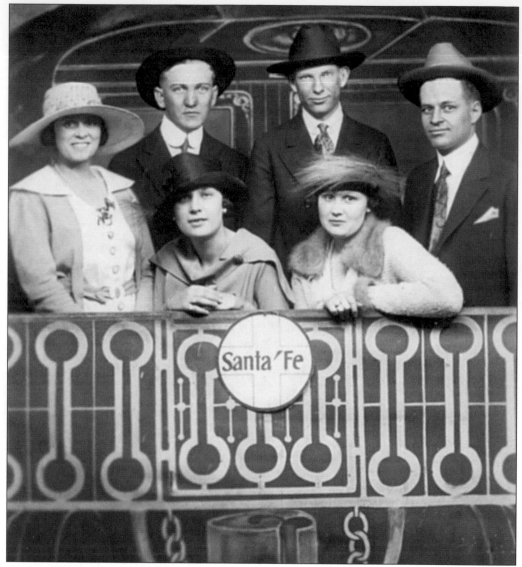

GROUP PORTRAIT. Fueled by the oil strikes in West Texas, the continued growth of the Stockyards, expanding rail operations, and a population that topped 100,000, Fort Worth entered the 1920s with an unlimited horizon. The city was home to nine oil refineries and nearly 350 individual oil companies. Cars were being manufactured at the Chevrolet Plant on Seventh Street and at the Texan factory on McCart. Annexations in 1922 doubled the size of the city by taking in Polytechnic, Arlington Heights, Riverside, and Niles City. In 1925 Fort Worth adopted a new city charter doing away with the old alderman and ward system and implementing the council-manager form of government. The same year voters approved a $7.6 million bond package, the largest ever passed by a Texas city up to that time, to meet the needs of the recently expanded city by building new streets, water and sewer connections, and new parks. All the while downtown was being transformed as newer and taller buildings began to dominate the skyline. It was a fine time for a group of friends to stop by the Electric Post Card Studio at 1309 Main Street to have their picture taken on the painted platform of a fanciful Santa Fe passenger car. (Electric Post Card Studio, *c.* 1920.)

Four

1920–1930

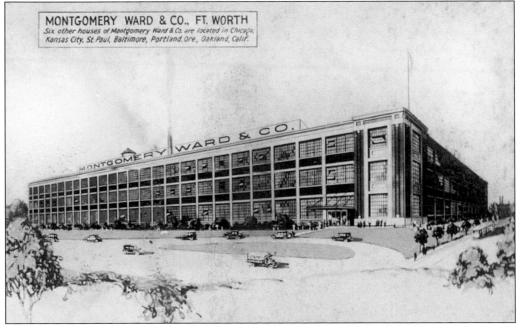

MONTGOMERY WARD & CO., FT. WORTH
Six other houses of Montgomery Ward & Co. are located in Chicago,
Kansas City, St. Paul, Baltimore, Portland, Ore., Oakland, Calif.

MONTGOMERY WARD & CO. Before the 1928 construction of the magnificent mission style catalogue warehouse across Seventh Street, Montgomery Ward operated from the building shown here beginning in 1924. Originally built in 1915 as a Chevrolet assembly plant, the building was expanded in 1920 before the auto manufacturer left Fort Worth after special flood control taxes were levied following a major flood in 1922. After Wards moved, the facility was used by a variety of manufacturing businesses and finally demolished in 1986. In 2003, the historic Wards property across the street was scheduled for redevelopment as a mixed-use retail and residential project. (Unknown Publisher, c. 1925.)

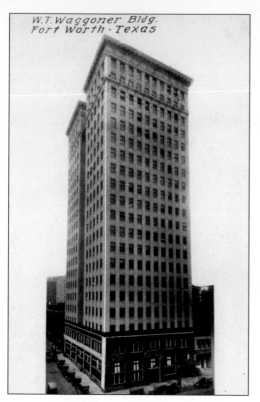

W.T. Waggoner Building. The Waggoner name had become synonymous with the cattle industry after W.T. Waggoner's father, Dan Waggoner, had taken some of the earliest herds up the trail beginning in the 1860s. Dan built an enormous ranch of more than 600,000 acres on which oil was discovered during the great West Texas strikes. Not to be outdone by his friend and fellow cattleman Burk Burnett, whose 14-story office building was the tallest in town, W.T. Waggoner commissioned Sanguinet and Staats to design a 20-story tower that, when completed in 1920, took the tallest honors not only in Fort Worth, but across most of the Southwest as well. Restored in 1984 the building is listed on the National Register of Historic Places. (Unknown Publisher, *c.* 1921.)

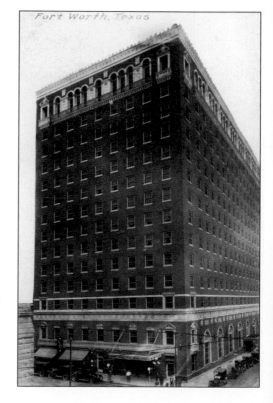

Hotel Texas. On September 30, 1921 the $4 million Hotel Texas opened near the site of the former Worth Hotel at Eighth and Main Streets. Conceived a decade earlier by Winfield Scott, who's Metropolitan Hotel was in the next block south, the construction was delayed when Scott died in 1911. His widow, Elizabeth Scott, and several local business leaders formed the Citizens Hotel Company to complete the project. Designed by Sanguinet and Staats, and originally called the Winfield Hotel, it was renamed before the formal opening. It was in Suite 805 of the hotel that President and Mrs. John F. Kennedy spent the night of November 21, 1963 before delivering his last speeches the next morning on his way to Dallas. (Unknown Publisher, *c.* 1921.)

QUEEN TUT. The Fort Worth Zoo was established in 1909 and soon after moved to new facilities in Forest Park. Among the greatest attractions of the early years was Queen Tut, an Indian elephant whose acquisition was supported by money donated by Fort Worth schoolchildren. She arrived on October 20, 1923 when she was three years old and weighed 1,100 pounds. The special rock house built for her, today the oldest structure in the zoo, had to be enlarged as she grew to her adult weight of 17,000 pounds. Queen Tut was the first superstar for the zoo that is now recognized as one of the finest in the country. (The Ledger Co., *c.* 1925.)

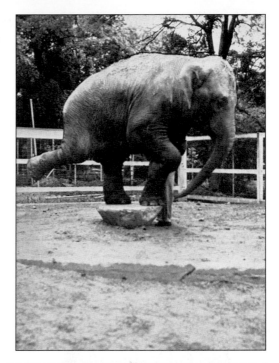

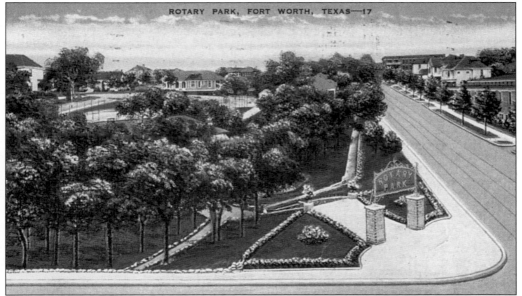

ROTARY PARK. The Rotary Club of Fort Worth was organized in 1913 and conducted its early meetings at the Seibold and Metropolitan Hotels. Harry J. Adams, president of Sandegard Grocery Company and a club founder, was impatient with the slow pace of park development in Fort Worth. He called on the club to raise money to acquire parkland and to support the fledgling park department. In 1916 the club purchased the southeast corner of West Seventh Street and Summit Avenue and built a small bath house and headquarters in the new park that would be home to the department until after World War II. Sold by the city after the war, the property today is the site of a convenience store opened in 2002. (Seawall Specialty Co., *c.* 1918.)

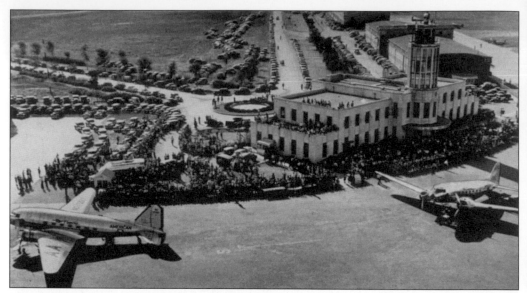

MUNICIPAL AIRPORT. Fort Worth fell in love with aviation from the arrival of the first planes in the city in 1911. Three airfields were built to train Royal Canadian Flying Corps pilots during World War I, and the city acquired a hundred acres north of town after the war on which to build a new field to assure Fort Worth a place on the rapidly developing air ways network. Instrumental in the development of the airport, which opened in 1925, were Mayor H.C. Meacham, for whom the field would be renamed in 1927, and A.P. Barrett, whose efforts would lead to the development of Fort Worth as a major aviation center. This image shows the airport following a major expansion and construction of the new terminal in 1937. (Graycraft, *c.* 1939.)

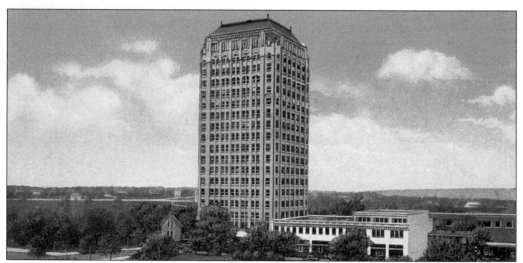

MEDICAL ARTS BUILDING. Houston developer Jesse H. Jones, recognizing the potential of Fort Worth's booming economy, established his Fort Worth Properties Corporation in 1926. One of his first projects was the 1927 Medical Arts Building, designed by Wyatt C. Hedrick, a former partner of and successor to the 30-year legacy of Sanguinet and Staats. The 18-story building, long considered one of the city's most elegant, faced Burnett Park, a gift to the city from Burk Burnett in honor of his children. The building was demolished in 1974 to make way for the construction of the 40-story Burnett Plaza. (Curt Teich, *c.* 1929.)

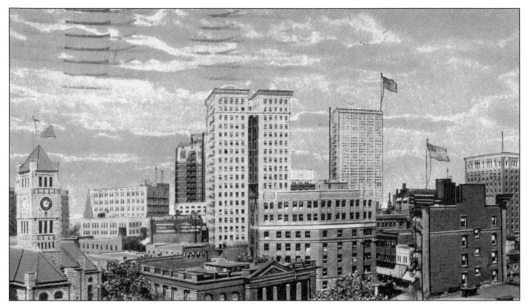

BIRD'S-EYE VIEW. The city skyline began to change dramatically during the 1920s. This view from atop the federal building looks across a foreground little changed for two decades with the 19th century city hall, and the early 20th century Carnegie library, Western Bank, and Flatiron Building. The 20-story W.T. Waggoner Building looms large at center. The Texas Hotel is seen at far right while the new Farmers and Mechanics Bank rises in the right center, taking the tallest building honors. (E.C. Kropp, *c.* 1924.)

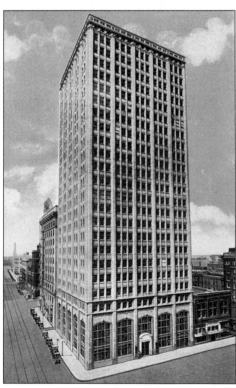

FARMERS AND MECHANICS NATIONAL BANK. Founded in 1889 by John Hoxie, a Chicago businessman and early organizer of the Stockyards, the Farmers and Mechanics Bank grew into one of the major financial institutions in town. In 1920 architects Sanguinet and Staats designed this 24-story headquarters that stole the tallest building honors from the W.T.Waggoner Building. Perhaps having extended itself too far to fund construction, the bank was acquired by the Fort Worth National Bank in 1927, which took over the building as its new headquarters. Maj. K.M. Van Zandt, who had founded Fort Worth National in 1873, was still president of the bank, a position he would hold until his death at age 93 in 1930. (Curt Teich, *c.* 1925.)

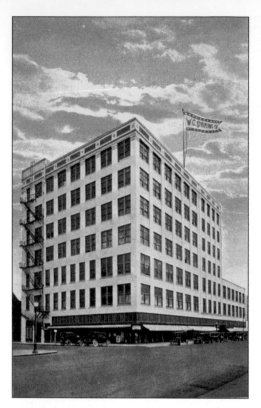

W.C. STRIPLING CO. Born in 1859, Wesley Capers Stripling grew up during the frontier days of Montague County before coming to Fort Worth to establish a dry goods store that would grow into one of the city's major retail operations. By the 1920s Stripling's covered nearly the entire block at Houston and Third. Generations of Fort Worth families recall the magical store displays during the holiday seasons. The company later merged with R.E. Cox & Co., another major retailer, to form Stripling & Cox. The store building downtown was demolished in 1979 to make way for the Renaissance Worthington Hotel. (E.C. Kropp Co., c. 1925.)

AVIATION BUILDING. Built on the northeast corner of Main and Seventh streets, the Aviation Building was considered one of the finest Art Deco structures in Fort Worth until its demolition in 1978. Begun in 1929 by A.P. Barrett, whose business interests included Southern Air Transport, a predecessor company to American Airlines, and Dixie Motor Coach Company, the building was designed by Herman P. Koeppe, an architect working with Wyatt C. Hedrick. Remarkable for its Mayan and Aztec themes, the building's entrance featured two cast concrete figures dubbed the "Aztec Princes" that were salvaged before the structure was imploded. Their location today is a mystery. Next door to the Aviation Building was the New Opera House, by 1929 converted to a movie theatre and renamed the Palace. (E.C. Kropp Co., c. 1930.)

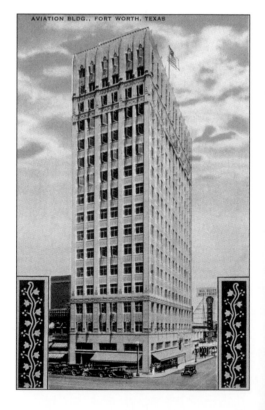

70

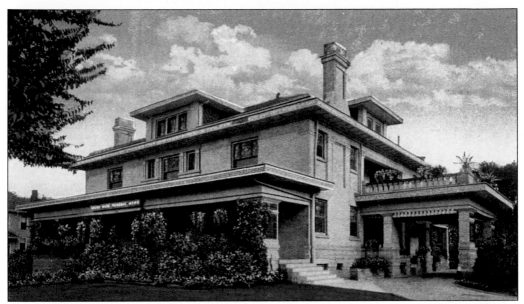

GAUSE-WARE FUNERAL HOME. George L. Gause arrived in Fort Worth in 1870, studying law with his father, W.R. Gause, who would later represent Tarrant County in the Texas Legislature. George Gause chose to pursue other interests and in 1876 opened the Missouri Wagon Yard at Weatherford and Taylor Streets. In addition to boarding and leasing animals and vehicles, he also supplied hearses for local funerals. After studying embalming he started the family business that would endure for nearly a century. By the late 1920s the company occupied this former private mansion at Pennsylvania and Fifth Avenues, whose owners had moved on to a newer "Silk Stocking Row." (Hermann Post Card Co., *c.* 1929.)

OUR LADY OF MERCY MISSION. This small church on Evans Avenue was established in 1929 by the Josephites, a Catholic order organized during the 19th century to minister exclusively within the African-American community. The church operated a school nearby, both under the early leadership of Father N.P. Denis and Mrs. Roberta Curry Lindsay. Since 1955 the building has been the home of the Sunshine Cumberland Presbyterian Church, and an important anchor along the redeveloping East Rosedale/Evans Avenue Urban Village. (Albertype, *c.* 1930.)

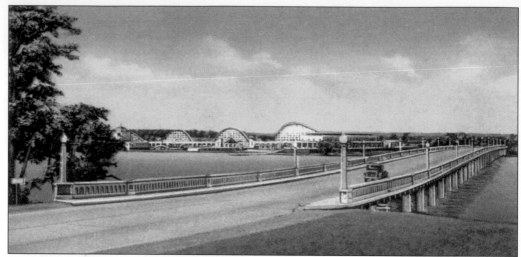

NINE MILE BRIDGE AT LAKE WORTH. The new Nine Mile Bridge opened in 1928, replacing the old wooden bridge that had been damaged by fire and rebuilt in 1922. The lake continued to serve as the recreational center for the city and, by 1926, more than 800 individual campsite leases lined the shore. That year the Fort Worth Power Boat Association hosted speedboat races to an audience of 30,000. A 600-passenger pleasure boat, the "Alvez," made regular day and nighttime trips around the lake until it caught fire one night in 1928 and sank at the foot of Mosque Point. All aboard escaped injury. As the lake became more popular city officials considered ways to improve the public facilities and develop a year round attraction. (Curt Teich, *c.* 1930.)

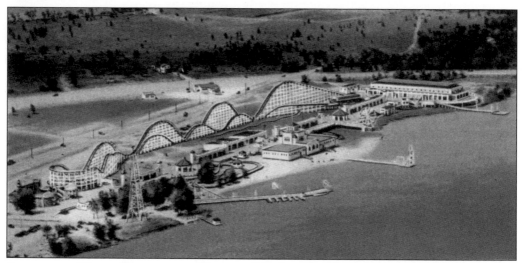

AEROPLANE VIEW—BEACH AND CASINO. Billed as the "Coney Island of the Southwest," Casino Beach opened in 1927 following a deal between the city and developers to create a million dollar amusement park at the site of the old bathing pavilion. One of the largest roller coasters in the country provided the backdrop for a wooden arcade and boardwalk that included a small zoo. At the north end of the complex was the casino itself, a massive entertainment facility with a ballroom accommodating 2,000 people. Until its closure in the 1960s, the casino hosted some of the most popular and famous dance bands in the country. The arcade and casino burned in 1929, but they were rebuilt and reopened in time for the 1930 summer season. (Curt Teich, *c.* 1930.)

BOARDWALK—CASINO BEACH. One of the more unusual structures on the Boardwalk was this fanciful character, modeled after Bluebeard the Pirate, at the southern end of the park. Part of the original 1927 park design, the head served as the ticket booth and entryway to the park when the main entrance to the beach was from the old Nine Mile Bridge. Visitors to the beach in January 1930 witnessed a scene never repeated in Fort Worth when the lake froze over solid enough for cars to drive out onto the surface. The last vestiges of the Casino Beach development were demolished in 1991. (Realphoto, 1928.)

MISS LAKE WORTH. Beginning her service in 1919, *Miss Lake Worth* continued to ferry passengers around the lake through the 1920s. The pleasure boat *Panther City* began service the same year but burned in 1922, taking part of the old wooden bridge with her. Boating was a major activity on the lake from the time E.P. Haltom launched his home built sailboat in 1913. Sitting around the kitchen of Marion Herring's Boat Works in 1929 a group of young sailing enthusiasts, including Haltom and George Q. McGown Jr., many of whom had started the Fort Worth Power Boat Club years earlier, formed the Fort Worth Boat Club. Herring was a master mechanic known for keeping the engines in top shape for his wife Ruth, a championship hydroplane racer who chalked up four world speed records among her 100 racing wins. (Realphoto, *c.* 1927.)

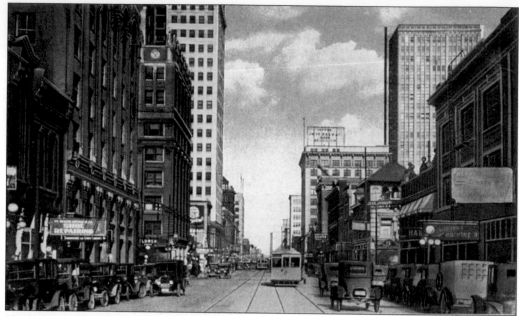

HOUSTON STREET. Automobiles still competed with streetcars along the length of Houston Street during the boom years of the 1920s. Down the left side of this image are the Flatiron Building and the former Western National Bank building shown here with additional floors added by the Texas State Bank in 1918. Behind it looms the W.T. Waggoner Building, while down and across the street are the First National Bank and the Farmers and Mechanics National Bank buildings. At the far end of the street is the smokestack of the electric plant adjacent to Paddock Viaduct. (Curt Teich, *c.* 1927.)

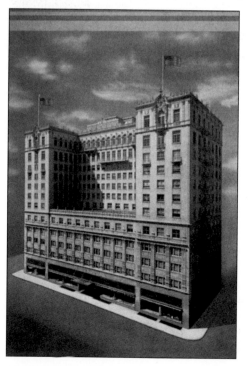

FORT WORTH CLUB. By 1919, the Fort Worth Club was outgrowing its building at Sixth and Main. The club settled on a new location at Seventh and Throckmorton during a period that saw Seventh Street become the business and financial hub of the city. Designed by the firm of Sanguinet, Staats and Hedrick, the new building was championed by Amon Carter, the dynamic *Star-Telegram* publisher and city promoter who led the campaign to finance the new headquarters. The first event held in the new club was the 1926 Steeplechase Ball, still associated with annual Stock Show, at which the Queen of the Show and her court, all daughters of Fort Worth Society, were presented to the community. Queen Evelyn Smith recalled Mr. Carter's nervous watch over party guests to make sure they didn't scratch the new floors. (Graycraft, *c.* 1929.)

ELECTRICAL BUILDING. Another project of Houston developer Jesse Jones, the 18-story Electric Building opened in 1929 at the gateway intersection of Seventh and Lamar. The building took its name from the lead tenant, the Fort Worth Power and Light Company, advertised by two six-story tall signs attached to the structure. Company employees suspected something was happening when the signs were taken down almost immediately. When the signs went back up a few months later, they carried the name of Texas Electric Service Company that had purchased the old Texas Power and Light. The building was renovated in the mid 1990s and converted to residential use. (E.C. Kropp, *c.* 1929.)

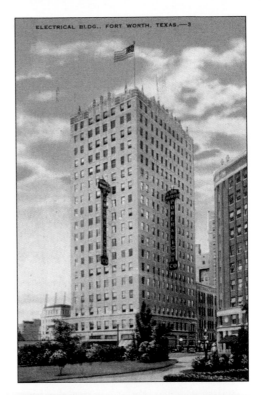

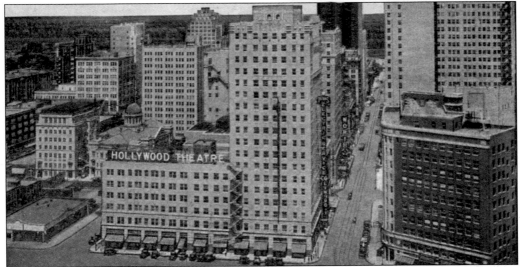

SEVENTH STREET CANYON. Shortly after construction of the Electric Building, a wing was added to accommodate the Hollywood Theatre, an Art Deco movie house. Portions of the lobby and balcony remained after the conversion of the building to apartments, and a parking garage was built inside the old theatre auditorium. At right in this image is the 1921 Neil P. Anderson Building. Saved from demolition, the building was restored to house offices and retail shops, at the same time preserving the top floor cotton showroom built for the Neil P. Anderson Cotton Company. In an ever-changing city, the two historic buildings have welcomed generations of visitors to downtown Fort Worth. (E.C. Kropp, *c.* 1931.)

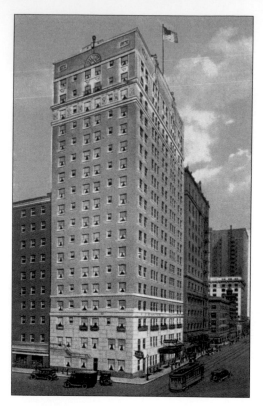

WORTH HOTEL. Opening in September 1927, the "new" Worth Hotel, with its 300 rooms, each with a private bathroom ceiling fan, quickly became one of the top hotels in town. Adjacent to the hotel was the Worth Theatre, a magnificent movie palace built in an Egyptian motif, and one of three movie houses that made Seventh Street an entertainment center for generations. By 1971 the theatre had closed and the hotel was no longer the best guest address in town. Purchased by the Fort Worth Club to allow for construction of a parking structure and expansion of the club facilities, the hotel and theatre were imploded in 1972. (Curt Teich, *c.* 1927.)

ELKS CLUB. Designed by Wyatt Hedrick and built in 1928, this facility replaced the 1910 mansion-style Elks club around the corner at Seventh and Lamar. The new building had rooms for visiting members, recreational facilities, and a grand ballroom on the second floor, all richly decorated and containing hardware cast with sculpted elk heads. When the club moved to a newer facility on Bailey Avenue in the 1950s, the old building was purchased by the Young Women's Christian Association, which still owns the historic structure, providing childcare services and residential support. Restored in 1990 with support from the Historic Preservation Council for Tarrant County, the building is listed on the National Register of Historic Places and is also a Recorded Texas Historic Landmark. (Curt Teich, *c.* 1929.)

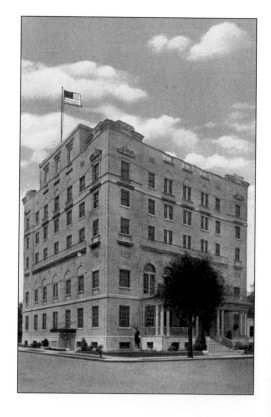

BLACKSTONE HOTEL. Since its opening in 1929, the Blackstone Hotel has remained one of the most distinctive buildings on the Fort Worth skyline. Built for C.A. O'Keefe, who had made a fortune in cattle, insurance, and oil, the hotel hosted presidents and celebrities, and was home to the 22nd-floor studio of WBAP radio, in which Bob Wills recorded his "San Antonio Rose." The hotel finally closed in 1982 and was sold out of foreclosure to two local investors who, through all the ups and downs of the economy during the 1980s, managed to save the building for its eventual renovation by Marriott Corporation and its return to life as an Art Deco masterpiece. (E.C. Kropp, *c.* 1930.)

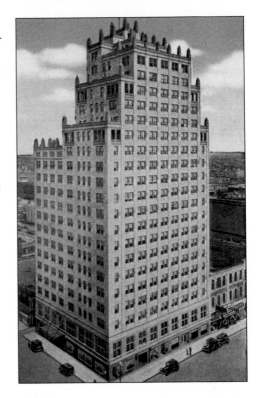

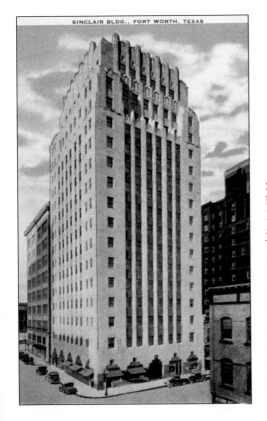

SINCLAIR BUILDING. The final downtown building project announced in 1929 was the R.O. Dulaney Building at the corner of Fifth and Main Streets on the site of the 1904 Fort Worth National Bank Building. Renamed the Sinclair building after Sinclair Oil Company leased several floors, the Zigzag Moderne structure designed by Wiley Clarkson opened in 1930. Architect Ward Bogard, who had overseen the 1984 restoration of the Tarrant County Courthouse, supervised the renovation of the Sinclair Building in 1990, recreating its magnificent lobby, and returning to use another of Fort Worth's prized examples of Art Deco design. (E.C. Kropp, *c.* 1930.)

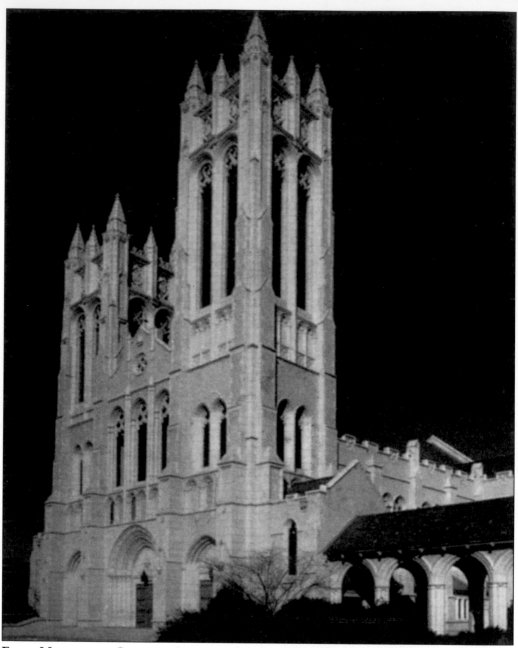

FIRST METHODIST CHURCH. As a new decade approached, the expanding membership of First Methodist Church had outgrown its 1908 sanctuary at Seventh and Taylor streets. On October 29, 1929 the congregation gathered for a groundbreaking ceremony for a new sanctuary at Fifth and Florence. Designed by Wiley Clarkson, the Gothic revival church remains a major downtown landmark. The main speaker at the laying of the cornerstone in October 1931 was Congressman Fritz G. Lanham, who served Fort Worth in the U.S. House of Representatives from 1919 to 1947. He and the other members of the Texas delegation would help Fort Worth and the state weather the coming depression by providing massive amounts of financial support through various government programs. (Graycraft, *c.* 1940.)

Five

1930–1940

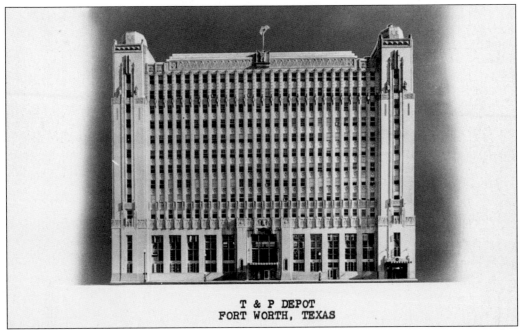

T & P DEPOT
FORT WORTH, TEXAS

T&P DEPOT. Even though the city had grown tremendously over the prior two decades, much of the road and rail infrastructure had not. The Texas & Pacific Freight Lines still extended down Front Street, all the way to Main at the south end of downtown, while many rail crossings remained at grade, or utilized 19th-century bridges and viaducts. John L. Lancaster, president of the T&P, met with city officials to develop an ambitious joint program of street, bridge, and rail realignments and improvements, including the construction of a new passenger depot to replace the aging depot built in 1900. The crown jewel of the project was this 1931 Art Deco masterpiece designed by Wyatt Hedrick's architectural firm under chief designer Herman P. Koeppe. After undergoing a $2.5 million restoration of the lobby and passenger spaces by the Fort Worth Transportation Authority in 1999, the historic depot serves as the western terminus of the Trinity Rail Express. (Unknown Publisher, *c.* 1935.)

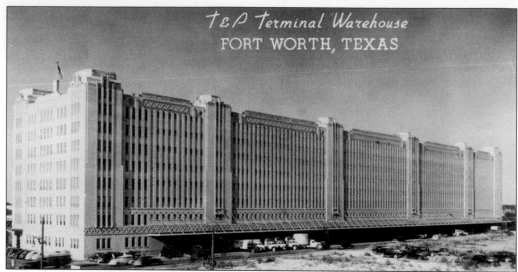

T&P TERMINAL WAREHOUSE. Concurrent with construction of the new passenger depot, the T&P built a massive 611-by-100-foot, eight-story freight warehouse, and relocated rail tracks to the south of the new buildings. The city and the railroad then redesigned most of the major intersections, replacing the old grade crossings with new over and under passes at Main, Jennings, and Henderson, while Front Street was renamed for T&P President Lancaster. Built during the heyday of rail service, the complex eventually succumbed to the rise of truck and automobile transportation as passenger service ended in 1967 and the warehouse was sold in 1978. With the development of the Lancaster Corridor following the relocation of Interstate 30, and the removal of the old elevated section in front of the building, the warehouse is a prime candidate for adaptive reuse. (Unknown Publisher, *c.* 1940.)

T&P DEPOT TICKET OFFICE. The old 1900 Texas & Pacific Passenger Station remained in use during the construction of the new station completed in 1931. This image shows the interior of the ticket office after 30 years of use and shortly before the old building's demolition. On the wall next to the ticket window was an inspirational message provided by the company to its employees, which read, "We are never alone if we are accompanied by kind and noble thoughts." (Harold D. Conner, 1931.)

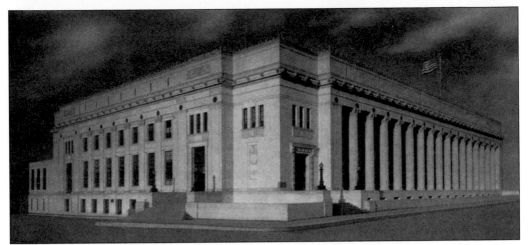

UNITED STATES POST OFFICE. The City of Fort Worth was well underway with its five-year work program of infrastructure improvements started in 1928 when the federal government announced plans for two major projects: a new United States Courthouse and a new post office to replace the aging 1896 federal building. Groundbreaking for the Wyatt Hedrick-designed post office took place in August 1931 with the monumental building opening to the public in 1933. Clad in limestone quarried near Austin, the building features 16 massive Indiana limestone columns topped by capitals adorned with longhorn and shorthorn cattle heads honoring the livestock heritage of the city. The $1.4 million project was the first of many federally supported programs that helped mitigate the increasingly harsh conditions of the Depression. (Graycraft Card Co., *c.* 1940.)

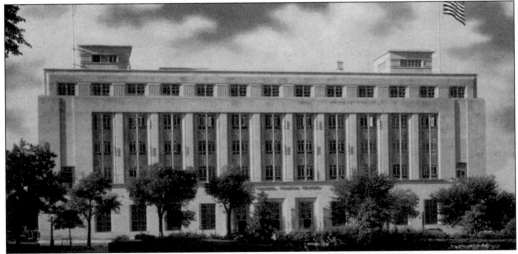

UNITED STATES COURTHOUSE. Nationally recognized architect Paul Philippe Cret of Philadelphia was selected to design the $1.2 million federal courthouse. Working on the project with local architect Wiley Clarkson, whose designs had helped introduce Art Deco themes to Fort Worth, Cret was already known in Texas as the designer of the 1930 master plan for the University of Texas campus that included the administration building and its landmark tower. Two murals in the U.S. Court of Appeals, on the fourth floor of the courthouse, were painted by Colorado artist Frank Mechau, and are the only art works funded in Fort Worth through the Federal Public Works of Art Project during the Depression. (Graycraft, *c.* 1940.)

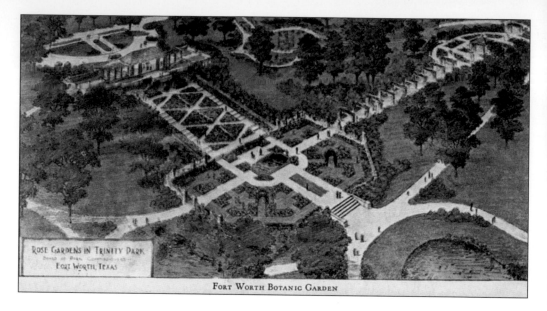

FORT WORTH BOTANIC GARDEN

MUNICIPAL ROSE GARDEN. The formal development of the Fort Worth park system began with the 1909 Kessler plan that called for the creation of parks along the Trinity River and its major tributaries. The city purchased the site of an abandoned gravel pit near the river in 1912 where, according to local legend, the first traders to venture into the area may have set up their camp in the early 1840s. After the passage of a bond package in 1925 the city hired the Kansas City landscape design firm of Hare and Hare to complete the work suggested by Kessler. With a loan from the Reconstruction Finance Corporation Fort Worth began its first depression-era relief project by constructing the Municipal Rose Garden. The Hare and Hare design called for the construction of terraces, shelters, and vistas to provide the background for the garden plantings. Several hundred skilled stone masons and builders worked for an average wage of four dollars a day to complete the project. City officials joined the workers and Fort Worth citizens to dedicate the Municipal Rose Garden on October 15, 1933. Two years later the name would change to the Fort Worth Botanic Garden.

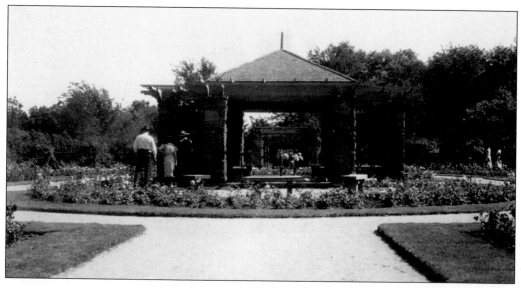

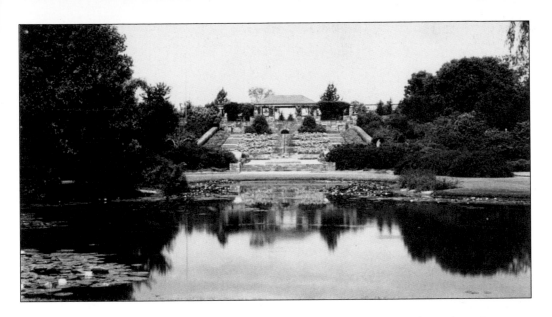

FORT WORTH BOTANIC GARDEN. The card at top left, published by The Ledger Company *c.* 1935, depicts the original design of the garden, with its formal symmetry and axes connecting the rose arbor to the terrace steps leading up to the garden pavilion. The lower left image shows a view looking down the length of the rose arbor back toward the terrace not long after the construction. The image above looks up to the pavilion from the lagoon, the reputed site of the 1843 traders' camp where Ed Terrell and John Lusk operated before being held captive by Native Americans for more than a year. The card below shows the view from the pavilion, across the terraced garden and the lagoon to the river at the far end of the vista. The rose garden and the surrounding botanic gardens remain among the most popular spots in Fort Worth. Over the years the Tarrant County Rose Society has planted more than 15,000 rose bushes in the garden, supplementing the original plants, many of which were donated to the park by the relief workers themselves. (Unknown Publishers, various dates 1935–1940.)

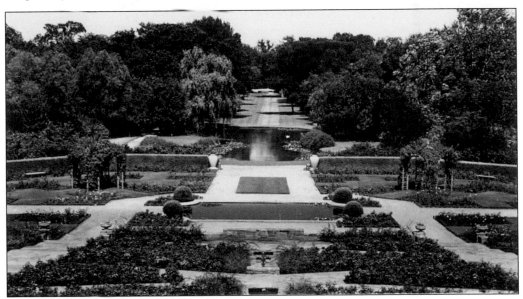

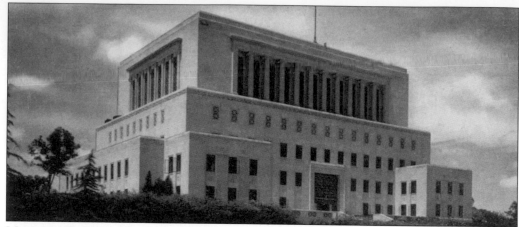

MASONIC TEMPLE. The first Masonic Lodge in Fort Worth held its initial meeting in April 1854. By 1920, ten Masonic organizations were finding it hard to schedule meeting times and locations. After years of discussing the construction of a combined Temple to provide adequate space for each of the lodges a Masonic Building Association was formed in 1926, hiring Wiley Clarkson to design a classical moderne temple on Henderson Street. The difficult economy required a scaling back of the proposed design by nearly half, but a cornerstone was finally laid in September 1931 and the first meetings were held in the not quite finished temple on May 12, 1932. (Graycraft, *c.* 1940.)

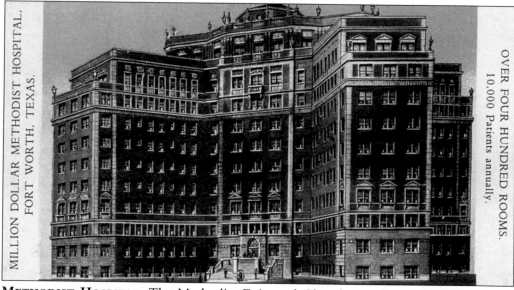

METHODIST HOSPITAL. The Methodist Episcopal Church, South, founders of what is today's Texas Wesleyan University, supported the development of a new hospital for a rapidly growing Fort Worth. The million-dollar Methodist Hospital opened in 1930 with a capacity to treat 10,000 patients annually in its 400 rooms. The economic pressures of the Depression nearly forced the hospital to close its doors. In 1937 Dr. Charles Harris merged his successful Harris Sanitarium with the hospital and guaranteed the outstanding debt. Today Harris Methodist Fort Worth is one of the top-ranked hospitals in the country. The original 1930 building shown here remains an integral part of the modern medical complex on Pennsylvania Avenue. (Wimberly-Hubbard, *c.* 1930.)

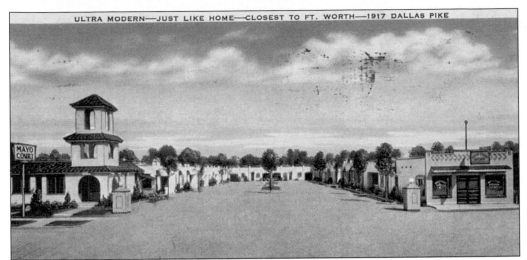

NEW MAYO COURT. U.S. Highway 80 was designated in 1926 and became the first transcontinental highway through the South. As the road made its way through Fort Worth it followed Lancaster Avenue and paralleled the route of the Interurban between Fort Worth and Dallas. As auto travel grew, the old Interurban right of way was taken to widen the highway and make room for more modern travel amenities, such as this motor court. The New Mayo opened about 1930 a mile east of the T&P Station, joining scores of similar properties scattered along the new federal highway. In addition to offering private baths "just like home," the New Mayo offered General Electric refrigerators, Beautyrest mattresses, and free ice water. (E.C. Kropp, *c.* 1936.)

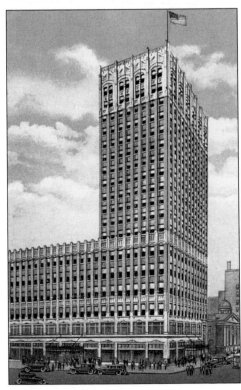

FAIR DEPARTMENT STORE. Established in 1890 as a variety store, the Fair grew into one of the city's major retailers. By 1930 the business was owned by Lionel C. Bevan who commissioned Wyatt Hedrick to design a new store and office building to replace the aging 1895 store headquarters on Houston Street. The new site, on the corner of Throckmorton and Seventh, put the store in the heart of the new commercial district, across the street from the Fort Worth Club and adjacent to the 1908 sanctuary of First Methodist Church, seen here in the lower right. The store closed in 1963, its space replaced by the Bank of Commerce and the Petroleum Club for a time. (Curt Teich, *c.* 1930.)

85

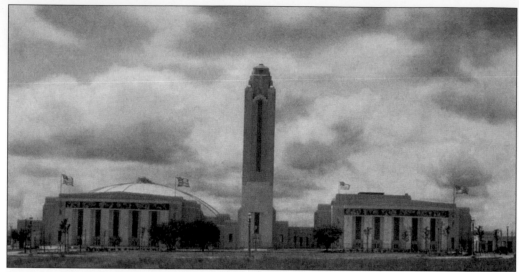

WILL ROGERS MEMORIAL COLISEUM, MEMORIAL TOWER, AND MUNICIPAL AUDITORIUM. The 1936 Texas Centennial of independence from Mexico provided Fort Worth with a distraction from the worsening times of the Depression. After long delays, and, ultimately with the help of city, state, and federal funding, the city planned a special centennial year production of the Southwestern Exposition and Fat Stock Show. The city commissioned Wyatt Hedrick and Herman Koeppe to design a new exhibits complex on the west side property once owned by Maj. K.M. Van Zandt. Working with Herbert Hinckley, who designed the innovative open span roof of the coliseum, Hedrick's team gave the city one of its most important landmarks. When humorist Will Rogers, a close friend of Amon Carter's and Fort Worth, died in a plane crash in 1935, the new center was named in his memory. (Graycraft, *c.* 1940.)

OUT WHERE THE FUN BEGINS. Even as plans were underway for the Centennial Stock Show, Fort Worth was determined to offer a celebration that could rival the official state centennial events set for rival Dallas. Amon Carter and a committee of local business leaders hired New York master showman Billy Rose to run the party for the princely salary of $1,000-a-day for 100 days. Rose brought to Fort Worth his entire production of "Jumbo," at the time one of the big hits on Broadway, enticed burlesque headliner Sally Rand to entertain with her "nude" dancers, and built one of the largest open air theatres complete with a water curtained revolving stage. Among the signature images of the Frontier Centennial were the drawings of scantily clad women produced by local artist Jewell Brannon Parker. (Curt Teich, *c.* 1936.)

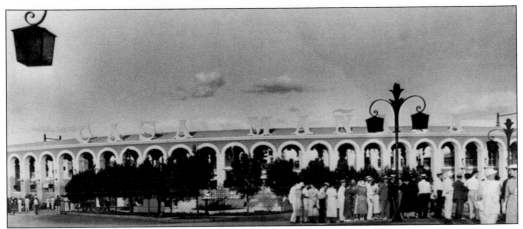

CASA MANANA. The main attraction of the Frontier Centennial was the 4,000-seat amphitheatre and café dubbed Casa Manana, or House of Tomorrow, by Broadway veteran John Murray Anderson, stage director for the entire celebration. Featuring the largest revolving stage in the world, the theatre also boasted the world's longest bar, a fitting attraction for a city that built its reputation on fun. With the open call of "Fort Worth for entertainment; Dallas for education," Centennial promoters tweaked Dallas further by erecting a giant neon sign outside the gates of Dallas' Fair Park advertising "Wild and Whoo-pee Forty-five Minutes West." Shown in this image is the massive 320-foot façade of the theatre as seen from Sunset Trail, one of the main avenues through the grounds. (Unknown Publisher, 1936.)

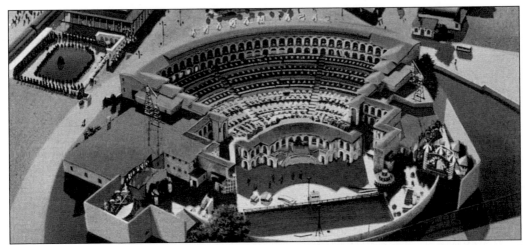

INTERIOR AND BACKSTAGE OF CASA MANANA. During one of the hottest summers on record The Fort Worth Frontier Centennial opened on July 18, 1936, when President Roosevelt, from the comfort of the presidential yacht off the coast of Maine, pressed a button sending a remote signal to a knife ready to cut the ribbon. Four months after the groundbreaking ceremonies bandleader Paul Whiteman and his orchestra played to a packed audience at the opening of the Casa Manana revue. The revue featuring Everett Marshall singing the show's theme song "The Night Is Young and You're So Beautiful," hastily composed in the Worth Hotel by 24-year-old Miss Dana Seusse with Billy Rose and John Murray Anderson. This view shows the massive stage that not only revolved but also moved forward and back on tracks hidden under the 130-by-175-foot lagoon. Various stage sets can be seen stored on either side of the stage. (Curt Teich, from an aerial photo by Ed Ritchie, 1936.)

SUNSET TRAIL. Taken from the roof of Casa Manana, this view looks back down Sunset Trail toward the massive theatre built to house Jumbo, Billy Rose's Broadway hit, transported in its entirety to Fort Worth. Temperatures reportedly hit 112 degrees inside the theatre, causing performers to faint and forcing star Eddie Foy Jr. to threaten to quit. Rose cut much of the show, including Foy's part, so that audience and actors would spend less time in the heat. The $300,000 state-of-the-art theatre never had the chance to show its full potential. At lower left was the Pioneer Palace, a saloon and dance pavilion that survived into the 1960s, long after the 1936 fairgrounds had been dismantled. (Unknown Publisher, 1936.)

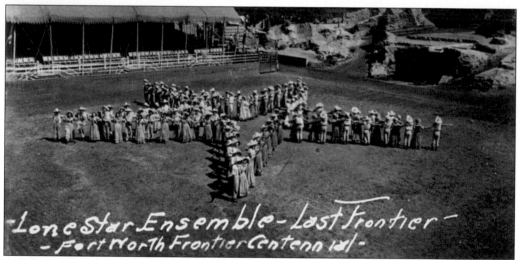

THE LAST FRONTIER. In addition to Casa Manana, Jumbo, and Sally Rand's Nude Ranch, the Frontier Centennial also staged an elaborate outdoor pageant called "The Last Frontier." Featuring trick ropers, bronc riders, archery, pistol shooting, and trick riding, the show also included 60 Sioux, members of the Second Cavalry, and 136 square dancers. This view shows the arena with its tented seating areas and man-made mountains surrounding members of the ensemble in their Texas star formation. The Frontier Centennial was unquestionably the highlight of the decade in Fort Worth and continued on for a couple of more years as the Frontier Fiesta before closing its doors. For more information about this remarkable event, read Jan Jones' book, *Billy Rose Presents . . . Casa Manana*, published by TCU Press. (Unknown Publisher, 1936.)

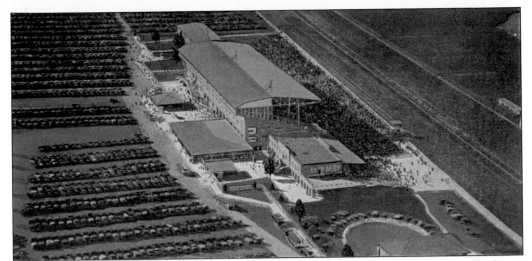

AERIAL VIEW OF ARLINGTON DOWNS. Another star attraction during the 1930s was the horse track at Arlington Downs, 16 miles east of Fort Worth along U.S. Highway 80. Owned by Fort Worth cattle and oil baron W.T. Waggoner and his family, the track was the centerpiece of Waggoner's Three-D stock farm that bred some of the finest horses in the country. At the time, the track was considered the best private racing facility in the nation, having cost a little over $3 million to develop. Waggoner built the 25,000-seat track in 1929 and lobbied hard to get the Texas legislature to legalize pari-mutuel betting in the state. His efforts paid off in 1933, but the success was short lived. Waggoner died in 1934 and, without his forceful presence, anti-gambling forces convinced the legislature to repeal the betting law in 1937. The facilities were eventually dismantled in 1958. (E.C. Kropp, *c.* 1930.)

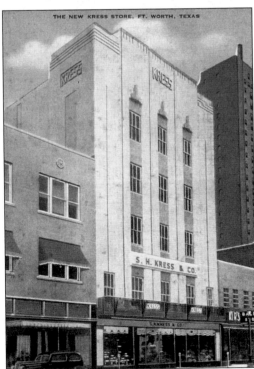

THE NEW KRESS STORE. While Fort Worthians were enjoying the distractions of the Texas Centennial, the S.H. Kress Company announced plans to build a new store downtown. Cutting through the entire block between Houston and Main Streets, the store was designed by Kress' in-house designer Edward Sibbert in Art Deco Classical Moderne style. After Kress relocated to a suburban shopping center in 1960, the building was home to Heritage Hall, a museum of pioneer life and later to a wax display of the Last Supper. The building today houses a pub and comedy club. (E.C. Kropp Co., *c.* 1936.)

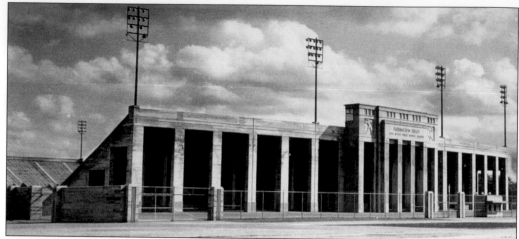

FARRINGTON FIELD. By 1937 more federal money was flowing to Fort Worth through the Works Progress and Public Works Administrations. The city was part of WPA District Seven that employed nearly 8,000 workers on 435 individual projects. One of the major projects approved in 1937, but delayed until 1939, was the Preston M. Geren designed Farrington Field. Named for former public school athletic director E.S. Farrington, the 20,000-seat stadium served all of the public schools, as well as Texas Wesleyan University before it disbanded its football program during World War II. The field also hosted other civic events, including the elaborate "Cavalcade of Fort Worth," celebrating the city's centennial in 1949. Featured prominently on the stadium facade are two cast sculptures executed by local artist Evaline Sellors, one depicting TCU football great "Slingin'" Sammy Baugh. (Unknown Publisher, *c.* 1940.)

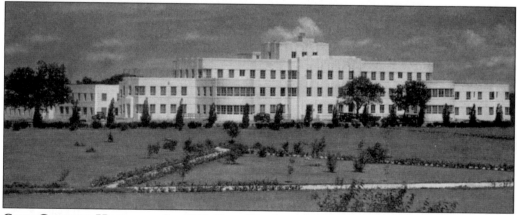

CITY-COUNTY HOSPITAL. In 1935 Fort Worth and Tarrant County voters approved a $300,000 bond package to fund a new hospital to replace an aging facility at Fourth and Jones Streets downtown. Plans were delayed when matching federal funds were diverted to the centennial celebrations, but the pressing need for a hospital for indigent patients, whose ranks were swelling as the Depression went on, prompted action. Construction on the Wiley Clarkson-designed hospital began in 1938 at a site on South Main Street, donated in 1877 by former mayor and city leader John Peter Smith, whose name the hospital bears today. The white limestone covered streamline Moderne building opened in 1939; the limestone is now buried under years of additions and expansions of the city's public hospital. (Graycraft, *c.* 1940.)

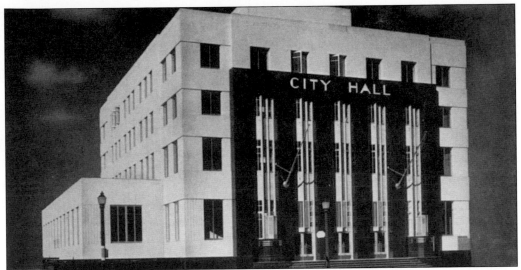

CITY HALL. In addition to funding the new city-county hospital, part of the $1.4 million federal PWA grant was earmarked for a new city hall and a new library. City leaders had complained for years about the inadequacy of the old stone city hall and were anxious to build a new facility to house offices and the jail. Voters approved another bond package to match the PWA money and construction began in 1938 on the Wyatt Hedrick–designed building on the site of the demolished 1893 municipal building. Opening in 1939, the building's architecture reflected the Machine Age influences of the late Art Deco period. When a new city hall was built in 1971, this building became the Municipal Courts Building. (Graycraft, *c.* 1940.)

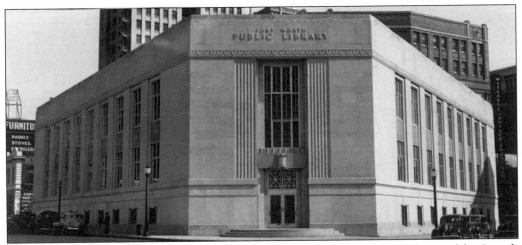

PUBLIC LIBRARY. Constructed during the 1930s, the public library was designed by Joseph Pelich, a leading local residential architect who had also designed the Frontier Centennial facilities. Built on the site of the old Carnegie Library, the new building was a marvel of modern design and provided four times more space, allowing for growth of the library and the collection of the Fort Worth Art Association that would eventually grow into the Modern Art Museum. When the city moved the library in 1978, the property reverted to the heirs of the land donors, who sold the property to a developer who demolished the building in 1991 to make way for a parking lot. Some of the salvaged Art Deco light fixtures now hang in the Intermodal Transportation Center on Jones Street. (Unknown Publisher, *c.* 1940.)

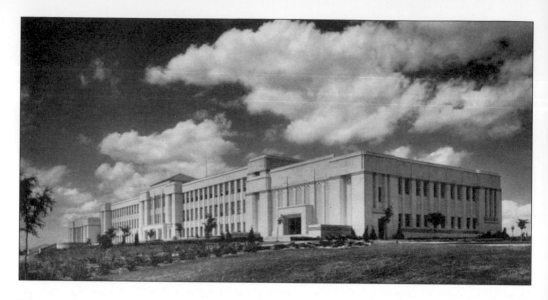

NORTH SIDE HIGH SCHOOL AND POLYTECHNIC HIGH SCHOOL. PWA funding was critical to the growth of the public school system during the Depression. Twenty-six school projects were completed using matching federal funds, including the construction of 13 new school facilities. Shown above is North Side High School, designed by Wiley Clarkson in 1937 and the only school built during this funding period in the Moderne style. Decorative landscaping complementing the building was carried out under a WPA grant that also funded local artists, supervised by Evaline Sellors, as they created cast-stone details for the building. A major characteristic of the schools built at this time was the location of the campuses. North Side, Polytechnic, and Arlington Heights High Schools were located on prominent hilltops with commanding views across the city. Joseph Pelich designed Polytechnic High School, shown below, in 1938 in a traditional Colonial Revival style overlooking Sycamore Park in east Fort Worth. Among the buildings on the Polytechnic campus is the former manufacturing plant of PolyPop, a popular powdered soft drink invented by neighborhood native and Polytechnic College graduate Paul Hollis. (Both images, Graycroft, *c.* 1940.)

U.S. NARCOTICS HOSPITAL. Another major federal project awarded to Fort Worth during the Depression, the U.S. Public Health Service Hospital covered over 1,300 acres on the city's far southeast side. Championed by Amon Carter, and secured with the help of Congressman Fritz Lanham, the facility was designed by Wyatt Hedrick and constructed between 1936 and 1939. The $4 million facility brought 500 precious jobs to the city and established an important federal institution serving the western half of the country. Designed for the treatment and study of narcotic addiction, the hospital had residential facilities for both voluntary and involuntary patients, as well as a working farm able to supply much of the food necessary to run the place. In 1971 the facility was converted to a minimum-security federal prison. (E.C. Kropp Co., *c.* 1939.)

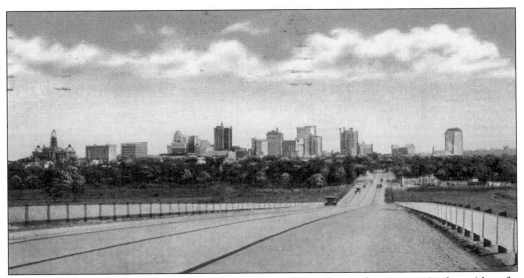

SKYLINE FROM NEW JACKSBORO HIGHWAY. As the 1930s began the city was in the midst of a massive five-year improvement plan that included streets, bridges, building construction, and advertisement to attract new business. This view toward downtown from the Jacksboro Highway crossing of the Clear Fork of the Trinity River shows the road under construction in 1930, and a skyline transformed by the boom years of the 1920s. To learn more about the remarkable decade of the 1930s and the rich architectural legacy of the Art Deco depression years, read Judith Singer Cohen's invaluable book *Cowtown Moderne*. (Post Office News, *c.* 1930.)

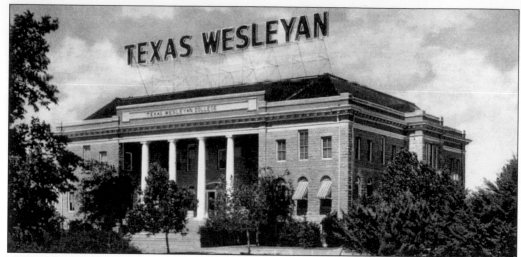

TEXAS WESLEYAN. After weathering the worst years of the Depression and readmitting men to the school that had been all female since 1913, Texas Wesleyan College hoped to enter the 1940s with renewed energy. In 1939 the school placed on the roof of its administration building a tall red neon sign that could be seen for miles. Ridiculed by students at first, the sign became a landmark that remained on the building for years. It is said that Dr. Law Sone, near the end of his 33-year tenure as president, removed the sign after hearing the story of a pilot lost on a foggy night who credited the sign with helping him regain his bearings. Praising the bright red sign, the pilot said he wanted one of those Texas Wesleyan beers to celebrate his safe return to earth. Dr. Sone ordered the sign down in 1967. (Albertype, *c.* 1939.)

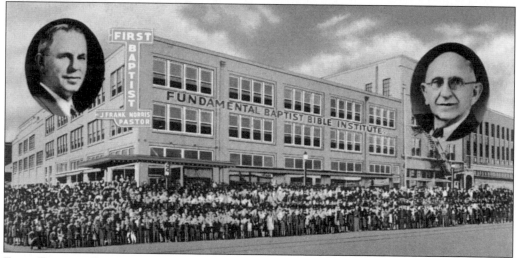

FIRST BAPTIST CHURCH. At the end of the decade, Dr. J. Frank Norris, shown left, celebrated his 31st year as pastor of a congregation that had grown to 12,000 members and claimed title to the largest Baptist Church in the world. The church facilities had grown to take up the entire block bounded by Throckmorton, Taylor, Third, and Fourth. Reverend Norris had survived threats, fires, and a murder trial to become one of the most influential and controversial figures in modern evangelism. By the time this card was printed, about 1939, Norris was commuting to another church in Michigan with a congregation equal to the Fort Worth church. J. Frank Norris died in 1952 and is buried in Fort Worth's Greenwood Cemetery. (Curt Teich, *c.* 1939.)

Six
1940–1950

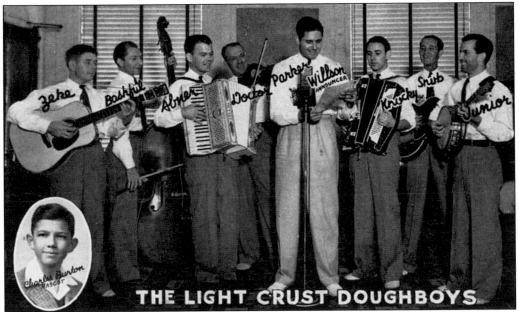

THE LIGHT CRUST DOUGHBOYS. Perhaps no band was more welcome into the homes of Fort Worth radio listeners than the Light Crust Doughboys. Beginning in 1929, when fiddle player Bob Wills convinced W.Lee O'Daniel, president of Burrus Mills, to sponsor the band, the group's popularity skyrocketed. Wills would leave in 1933 to form the Texas Playboys, and O'Daniel would use the Doughboys to win the Texas governorship in 1938. Ironically he had fired the group in 1931 because he didn't like their hillbilly music, but brought them back when Light Crust Flour customers demanded their return. By 1940 the band was carried on 170 radio stations in the South and Southwest. (Unknown Publisher *c.* 1938.)

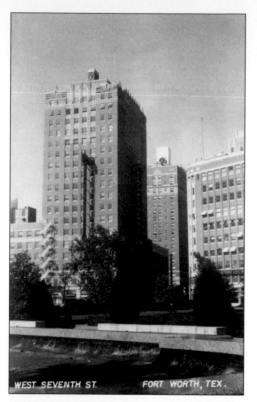

WEST SEVENTH STREET. Little had changed by 1940 around the Seventh Street entrance to downtown. The building boom of the 1920s had given way to the difficult days of the Depression, the effects of which had slowed the city's explosive growth with fewer than 15,000 new residents during the 1930s. The coming decade, however, would see the city nearly double in land area and increase the population by 100,000, taking it to 278,000 by 1950. This view looks across the old Burnett Park pond, undergoing its annual cleaning, to the Electric Building, the Worth Hotel and the Neil P. Anderson Building. War was already raging in Europe, but Fort Worth entered the 1940s confident and optimistic about its future. The Stockyards were still the biggest employer, a title that would shortly be taken away by the wartime bomber plant. The war would also force the relocation of the annual Stock Show to the Will Rogers complex, where it has remained ever since. In 1941 local golf legend Ben Hogan was the leading money winner in the country. That same year the U.S. Open was played for the first time in the South at Colonial Country Club. (Unknown Publisher, *c.* 1940.)

BAMBOO INN. "Steaks, Chop Suey and Authentic Cantonese Dinners" were the advertised fare at the Seibold Café and Bamboo Inn near the intersection of Camp Bowie Boulevard and Horne Street. The old Seibold Hotel and its café were located on the corner of Seventh and Commerce Streets. In 1918 the café was taken over by Hong Tom and Eng Wing, two entrepreneurs who introduced downtown customers to Chinese food. Family members continued to operate the downtown restaurant and, in 1949, expanded to the west side to take advantage of the post-war population boom. The distinctive tower was a Westside landmark until the restaurant closed in the early 1960s. (Artvue, *c.* 1949.)

MONNIG'S. William Monnig arrived in Fort Worth in 1889 and opened Monnig's Dry Goods Company, a name the store would carry until 1941 when it took on the name Monnig's Department Store. As owner of "The Friendly Store," William Monnig assumed many leadership roles in the community, including serving on the city council, as head of the Community Chest, and as a senior member of the Frontier Centennial Committee. His was the largest wholesale distributor of clothing in the city, serving a five-state region. He built a new store in 1925 at Fourth and Throckmorton, eventually expanding it to include the entire block. The store remained downtown long after other retailers had left for suburban sites, but finally closed in 1990. The building was demolished the following year to make way for expansion of Sundance Square. (Southwestern Engraving, *c.* 1940.)

LEONARD'S. From its humble start in 1918 in a rented space across the street from the courthouse, Leonard's grew into one of the leading retail operations in the country, eventually covering more than six square blocks of downtown and owning the world's only private subway. The Leonard family, beginning with brothers Marvin and Obie, helped define the spirit of Fort Worth as the store served customers from throughout North and West Texas. At its peak in the 1960s Leonard's had more than 500,000 square feet of sales space and employed 2,500 people. The store boasted the first escalator in town, and pioneered the retail "supercenter" concept where customers could find everything from fine dresses to farm equipment. One of the store's remarkable legacies is its role, lead by Marvin Leonard, to desegregate its facilities, first with its own employees in 1948 and soon thereafter with customers. Marvin Leonard sold his share of the store to his brother in 1964. Three years later, Tandy Corporation purchased the store and its property, eventually demolishing the retail legend to make way for the Tandy Center development that helped spark the revitalization of downtown. (Tichnor Bros. Inc., *c.* 1940.)

THE ORIGINAL MEXICAN RESTAURANT. The west side of Fort Worth began to develop rapidly following the end of World War I as builders took advantage of the streets and other infrastructure improvements made for Camp Bowie. The growing neighborhoods on either side of Camp Bowie Boulevard sparked commercial development that included restaurants, groceries, barbershops, and cleaners. One of the first commercial centers opened in 1926 in the 4700 block of the Boulevard. An early tenant was the Original Mexican Eats Café, which by 1945 was a well-established eatery, owned by G.P. Pineda. The restaurant is still in operation today under its "original" name. (Unknown Publisher, *c.* 1945.)

NEW ISIS THEATER. Built in 1935 the New Isis was the major movie house for the Fort Worth Stockyards and the thousands of families whose homes filled the adjacent neighborhoods. One of its most endearing promotions was the birthday pass, granting the bearer of the postcard greeting free admission. This image shows a theater full of over 900 North Side children in the audience with front row participants in costume, perhaps for a talent show. Manager L.A. Wallis' message on the card said, "We will expect you, so don't disappoint us." The New Isis has been closed for several years, but still presides over its corner of North Main and Northeast Twenty-fourth Streets. (Unknown Publisher, *c.* 1944.)

ROCKWAY COURTS & CAFE
5900 CAMP BOWIE
5 MI. WEST FT. WORTH - U. S. 80

ROCKWAY COURTS AND CAFÉ. As U.S. Highway 80 entered Fort Worth from the east, it followed along Lancaster Avenue until it intersected with Camp Bowie Boulevard which it followed to the western city limits. As had happened between Fort Worth and Dallas, small motor courts sprang up along Camp Bowie, including the Rockway Court at the intersection with Curzon. Typical of the period the complex contained a café and several tourist cabins, as well as a filling station. The roadside oasis was demolished to make way for newer development after World War II when A.C. Luther and others began to develop the Ridglea Hills area. (National Press, *c.* 1942.)

B-24 BOMBER. In 1941 the city council, on behalf of the U.S. Army, purchased over 500 acres near Lake Worth for the construction of a bomber factory. War seemed inevitable as Maj. Harry C. Brants, who had come to Fort Worth to train flyers for World War I, broke ground for the government plant operated by Consolidated Vultee Aircraft Corporation. The first B-24 rolled off the assembly line in April 1942 and, by 1944, more than 3,000 planes had been assembled at the plant. With 35,000 employees during the war, Convair became the city's biggest employer, stealing the distinction from the Stockyards. Adjacent to the bomber plant the Army built Tarrant Field in 1941 to train 4,000 B-24 pilots. Tarrant Field would be renamed for Major Horace W. Carswell, the first Fort Worth native to receive the Medal of Honor. (E.C. Kropp, *c.* 1944.)

NORTH SIDE HIGH SCHOOL FOOTBALL TEAM AND YELL LEADERS. While war efforts continued, much of life went on as usual. At North Side High School, the "A" Squad posed for a team picture in 1943. Joining them were the members of the Yell Team, with their megaphones announcing the team sponsors, including the New Isis Theater. The rich football legacy of North Side High School includes Bo McMillin, a star for the team from 1913–1917, who went on to play at Centre College before becoming a coach with the Detroit Lions and Philadelphia Eagles. Another North Side standout was Pro Football Hall of Famer Yale Lary, a member of the "A" squad in 1946–1947, who had a strong career with the Detroit Lions before returning home as a successful businessman in Fort Worth. (Unknown Publisher, 1943.)

WOLLNER HOMESTEAD. Carl Wollner and A.M. Pate Sr. founded Panther Grease Manufacturing Company in 1922 in a tin barn on Northeast Twentieth Street. The company grew into Texas Refinery Corporation, one of Fort Worth's oldest businesses. Wollner purchased land north of Fort Worth and tried his hand at small scale ranching. He also trained himself as a photographer, capturing this image of the homestead to send to his son Staff Sergeant Charles Wollner in 1944. (Carl Wollner, 1944.)

GRACE RIGGS LODGE. Every book should have a mystery, and this image is it. The Grace Riggs Lodge looks like it was a great place to relax with an interesting hostess. The property may have been on Lake Worth, but specific information was elusive. The author has no real information about the place at all, but included it in hopes that some reader might be able to shed some light on the Lodge and its owner. (Unknown Publisher, *c.* 1949.)

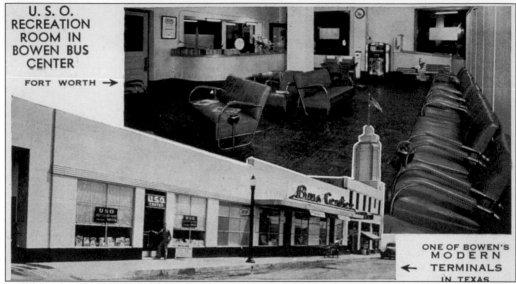

U. S. O.
RECREATION
ROOM IN
BOWEN BUS
CENTER

FORT WORTH →

ONE OF BOWEN'S
M O D E R N
← TERMINALS
IN TEXAS

BOWEN BUS CENTER. Brothers Temple and Chester Bowen began their transportation empire in 1923, operating a bus line between Fort Worth and Mineral Wells. It was later expanded to include service to Cisco, at the time bustling with oil operations. The Bowens later started Texas Air Transport Company, beating out Dallas competitors for the airmail routes linking Texas to the rest of the country. After the pioneer airline was purchased by A.P. Barrett, who would help it grow into American Airlines, the Bowens focused on their bus line and real estate investments. They hired architect Edward L. Wilson in 1941 to design a Streamline Moderne bus terminal at the intersection of Main and Lancaster directly across from the T&P Passenger station. The USO recreation room, added during the war, was a welcome stop for thousands of servicemen passing through Fort Worth by train or the National Trailways Bus System. (Unknown Publisher, *c.* 1943.)

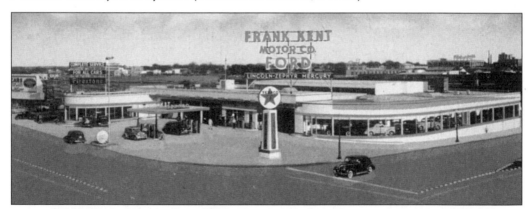

FRANK KENT MOTOR COMPANY. Across the street from the Bowen's bus terminal and built on the site of the 1900 T&P Passenger Station was the Frank Kent auto dealership. Also designed by Edward L. Wilson with James J. Patterson, the Streamline Moderne complex became a landmark in its own right until it was destroyed in a natural gas explosion after the dealership moved. Frank Kent arrived in Fort Worth in 1927, eventually buying the local Ford dealership and launching a successful career that placed him among the business and community leaders in the city. The Cadillac franchise that Kent obtained in 1953 still operates today and family members continue the long tradition of community service begun in 1927. (Southwestern Engraving Co., *c.* 1945.)

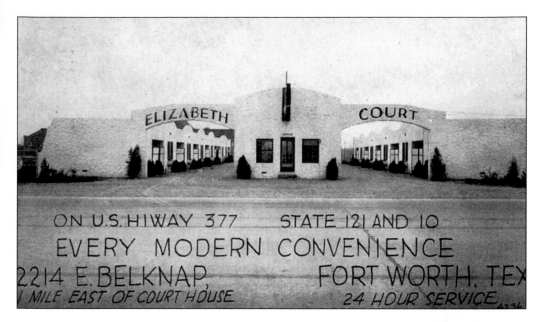

ON U.S. HIWAY 377 STATE 121 AND 10
EVERY MODERN CONVENIENCE
2214 E. BELKNAP, FORT WORTH. TEX
1 MILE EAST OF COURT HOUSE 24 HOUR SERVICE

SHADY TOUR REST AND ELIZABETH COURT. The motor courts that had been built along the highways around Fort Worth experienced a slump in business as travel was restricted by gas rationing during World War II, but found renewed use after the war ended and the city found itself in a serious housing shortage when servicemen returned home. Two of the pre-war compounds along U.S. Highway 377 are shown here. Above was the Elizabeth Court on East Belknap, demolished to make way for the I-35 and Airport Freeway interchange east of downtown. Below is the Shady Tour Rest, a heavily decorated version of its companion "Trav-O-Tels" built in 1934 with separate stone cottages and individual garages. This tourist camp still stands on East Belknap as a reminder of early days of automobile travel. (Top: Dexter Press, *c.* 1945; bottom: Curt Teich, *c.* 1946.)

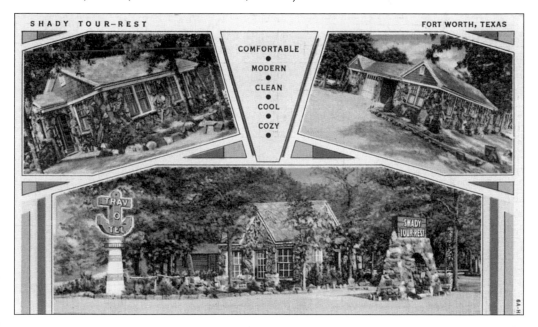

103

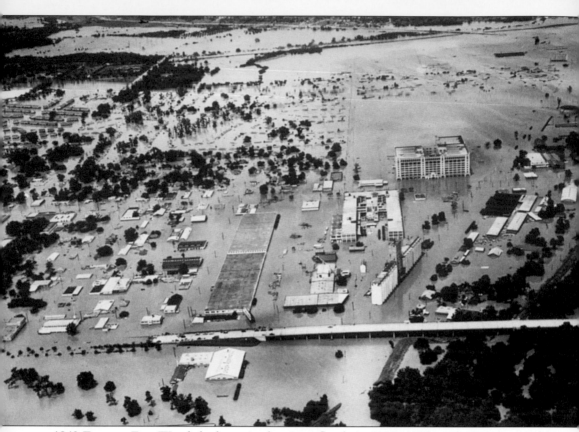

1949 Flood. Fort Worth had survived serious floods in 1908, 1922, and 1942, but nothing compared to the damage done in May 1949 as Fort Worth received a five-inch downpour that compounded heavy rains along the Trinity watershed. The flood that destroyed a thousand structures and did more than $11 million in damage left 13,000 homeless. These three images show the extent of the water coverage. Above is a view looking north toward the Lancaster and the Montgomery Ward building with water approaching the second floor.

The view at top right looks northeast from above North Main Street with LaGrave Field, home of the Fort Worth Cats, in the foreground. It was a tough year for the Cats. Just before the flood a fire swept through the ballpark's grandstand leaving twisted ruins behind. Undaunted, the team was back on the field within a week and diehard fans simply sat around the charred remains. The ballpark was demolished in the 1960s but a new one was built on the site in 2001 to provide a home to a new minor league team. The Cats are back.

The view at lower right looks southeast toward downtown from above Jacksboro Highway with the smokestacks of the Texas Electric Service Company plant and Paddock Viaduct at the top left of the image. One happy result of the flood was told by the owner of a building located not far from Montgomery Ward's. As the high water passed through his second floor windows, the floating contents of a nearby liquor store were deposited in the room, leaving at least some solace for the damage left behind. (Unknown Publisher, 1949.)

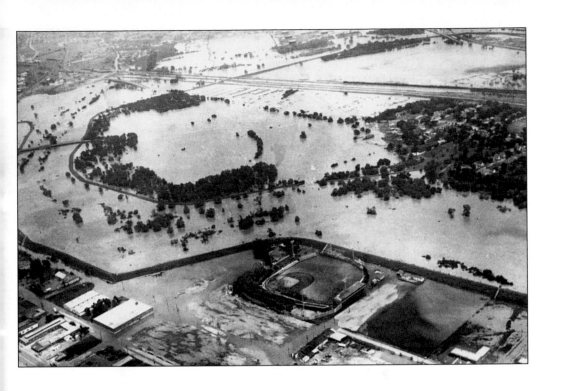

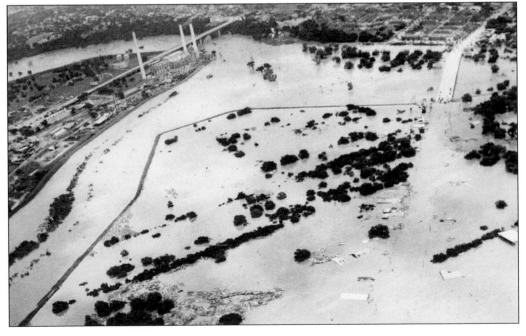

HOUSTON STREET. The 1950s would see Fort Worth continue to grow, albeit at a somewhat slower rate. By 1960 the population was 356,000, up about 30 percent since 1950. The decade was dominated by the postwar growth of the defense industries as Bell Helicopter relocated to the area in 1950, and Convair expanded under new owner, General Dynamics. The most contentious issue was the development of an airport to serve the region as Dallas and Fort Worth continued their age-old competition. The Stockyards had slipped from the 1944 peak of 5.25 million animals processed, and some city leaders began to express embarrassment about the city's livestock heritage. As new suburbs developed, many of the old mansions near downtown were demolished to make way for office buildings and, in 1955, the city lost its longtime booster and father figure Amon Carter. Many changes were ahead for the downtown area, but for the roving photographer who snapped pictures of downtown visitors, business continued on as usual. In the image above, the photographer captured a young James McMillin strolling down Seventh Street about the time he graduated from Texas Wesleyan College, now University, in 1955. Known to his friends and collectors all over the world as "Mac," he has taught countless people about postcards and helped build several collections, including the one featured in this book. (Unknown Publisher, *c.* 1955.)

Seven

1950–1960

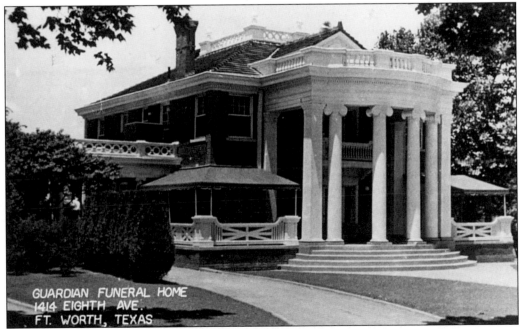

GUARDIAN FUNERAL HOME
1414 EIGHTH AVE.
FT. WORTH, TEXAS

GUARDIAN FUNERAL HOME. Walter B. Scott built his substantial home on Eighth Avenue in 1910 as the street was developing into a wealthy residential area. The local business leader was instrumental in developing plans to make the Trinity River navigable, a dream that did not really die until the 1960s. He had long since moved away from the central city when Guardian Funeral Home converted the property for other uses. Typical of the cycle that saw the grand mansions of the city converted to businesses or apartments before being demolished, the Scott property eventually became part of the All Saints Hospital campus. (Unknown Publisher, *c.* 1955.)

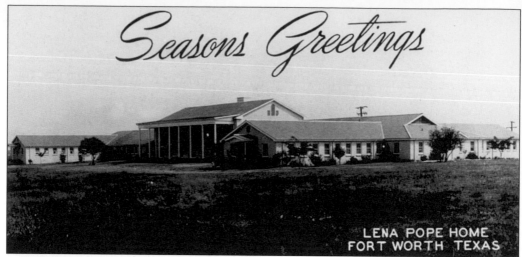

Seasons Greetings

LENA POPE HOME
FORT WORTH TEXAS

LENA POPE HOME. Called to care for children who had been orphaned, abandoned, or who simply needed someone to love them, Mrs. Lena Pope established a care facility in 1930. For almost 20 years the home operated in a converted residential property in the 4800 block of Camp Bowie. Mrs. Pope enlisted the support of some of the most powerful businessmen in town including Amon Carter, William Monnig, Marvin Leonard, and C.A. Lupton to help her realize in 1950 her long held dream of "a mansion on the hill" for her children. The columned Lena Pope Home was a landmark at Hulen and the west freeway for many years, until changes in the program and delivery of care prompted its demolition and replacement with detached family style homes for the residents. Today the elegant Marty Leonard chapel, designed by Fay Jones, stands at the site as a tribute to the longstanding involvement of the Leonard family. (Bill Wood Photo, *c.* 1955.)

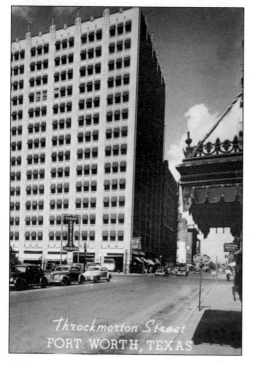

Throckmorton Street
FORT WORTH, TEXAS

THROCKMORTON STREET. This view looks east on Sixth Street across the intersection with Throckmorton with the 1927 Petroleum Building seen beyond the ornamental awning of the Fort Worth Club Building. By the time this image was made about 1950, the city had already begun to replace or pave over the downtown brick streets as part of its campaign to modernize the central business district. The process would take almost 15 years, culminating in the removal of several blocks at the south end of town for the convention center. (Unknown Publisher, *c.* 1950.)

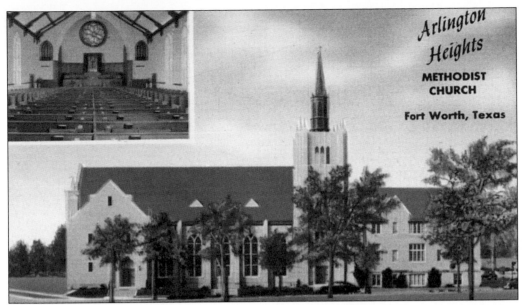

ARLINGTON HEIGHTS METHODIST CHURCH. Organized in 1922, the congregation conducted worship services and church activities in the 1927 Education Building for more than 20 years. In 1951 the church commissioned architect Birch Easterwood to design the sanctuary that was dedicated in November of that year. Installed in the bell tower was a symphonic carillon that could broadcast hymns up to three miles from the church. Adjacent to the church is a city park dedicated to the soldiers of the 36th Division who trained at Camp Bowie during World War I. (MWM Co., 1951.)

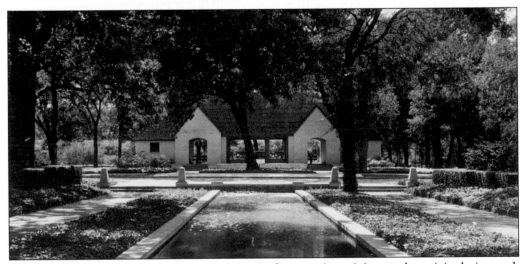

SHELTER HOUSE, TRINITY PARK. Trinity Park traces its origins to the original city park developed in 1892 on the land acquired for the Holly Water Plant. The city continued to expand the park property on the recommendation of the 1909 Kessler Plan, eventually using Depression-era funding and labor to build the shelter house around 1935. This view looks toward the shelter from West Seventh Street down the reflecting pond long since filled in. For many years the shelter, with its open-air stage, was home to "Shakespeare in the Park" productions. (Unknown Publisher c. 1955.)

L. White Boot and Saddle Shop. By the mid-1950s the Fort Worth Stockyards was processing less than half the animals it had just a decade before, down to 2 million from 5.25 million in 1944. Market changes, such as the rapid postwar development of remote auctions, had driven business away. In response, the North Fort Worth Business Association started a campaign to dress up the Stockyards and emphasize its western heritage. Part of the effort involved creating a frontier-town-feel by adding to the turn of the century buildings shingled awnings, cedar posts, and wooden sidewalks. "Go Western Week" in 1956 would evolve into the long running Pioneer Days Celebration. The Boot and Saddle Shop, shown here, joined the effort and proudly displayed its new look for a promotional postcard. (Unknown Publisher, *c.* 1956.)

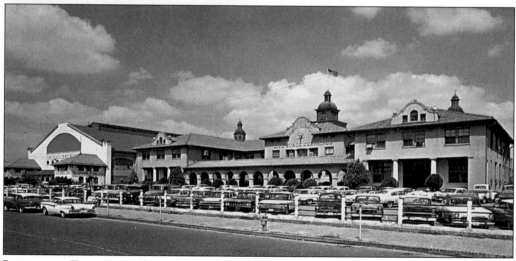

Livestock Exchange Building. While the other business owners in the Stockyards were doing their best to attract new customers, the Stockyards Company itself worked to keep the customers it had. One concession to the complaints that parking was inconvenient for the ranchers and their families was the 1956 paving of the Exchange Building front lawn and the addition of air-conditioned lounges inside the building. Six years later, the massive Armour plant closed, followed by Swift in 1971. This image was produced by John A Stryker, who's Western Fotocolor Company of Fort Worth produced hundreds of postcard images chronicling the city from the 1950s through the 1970s. (John A. Stryker, *c.* 1959.)

CONVAIR. When Consolidated Vultee opened its mile-long plant in 1942 to produce B-24s and other planes for World War II, it became the city's major employer. The company was acquired by General Dynamics in 1954 and continued to build large aircraft, including the giant B-36 intercontinental bombers shown here. Described as "Texas-sized," the planes had wingspans of 230 feet. By the time this card was published about 1958, the plant touted Fort Worth as "home to the world's largest integrated aircraft plant and the world's largest bombers," and was working on the country's first supersonic bomber. (John A. Stryker, *c.* 1958.)

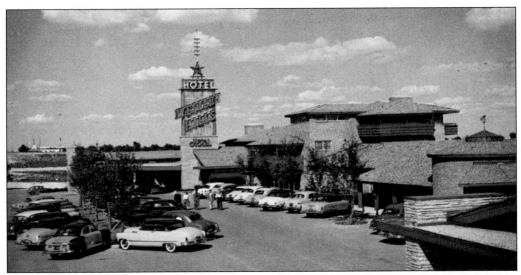

WESTERN HILLS HOTEL. With the explosive growth of the west side of the city, fueled in part by the success of the Convair Plant, A.C. Luther and a group of investors developed the Ridglea Hills subdivision. One of the showpieces of the area was the Western Hills Hotel, built on Highway 80 by Hank Green and partners. With over 200 rooms, detached cabanas, and honeymoon cottages, the hotel was an instant success. It even boasted the world's first hotel heliport, allowing guests to fly in to enjoy a steak in the Branding Room restaurant under a western mural painted by local artist Emily Guthrie Smith. The hotel was destroyed by fire in 1969. (John A. Stryker, *c.* 1955.)

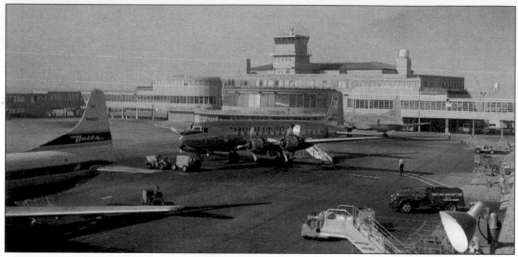

GREATER FORT WORTH INTERNATIONAL AIRPORT. Perhaps no other issue created as much controversy and competition between the cities of Fort Worth and Dallas as the location of an airport to serve the region. Talks about a "Midway" airport had been on the table for years by the time the cities agreed to a location and construction began in 1950. When dedicated in 1953 the airport was also known as Amon Carter Field in honor of the man who had fought so hard to make it a reality, and whose insistence that the terminal building face Fort Worth so irritated Dallas leaders that the feud continued. It took intervention by the federal government and the cool heads of leaders from both cities to craft the compromise that led to D/FW International Airport. All that remains of Carter Field is a small stretch of runway near the southern entrance to D/FW Airport. (John A. Stryker, *c.* 1956.)

SOUTHWEST AIRPORT. In keeping with the western spirit of the airport, the terminal lobby featured a gold leaf relief sculpture depicting the history of transportation in Texas. The restaurant was built on the upper level of the building with an expansive view of the runways and airport operations, while an open-air deck allowed visitors to greet passengers and watch planes land and take off. An unusual feature of the lobby was the set of world champion longhorns. Owned by M.K. Brown Sr., shown with cane, the horns measured nine feet two inches, and had been displayed at Madison Square Garden and the New York World's Fair. (Stryker's Western Fotocolor, *c.* 1965.)

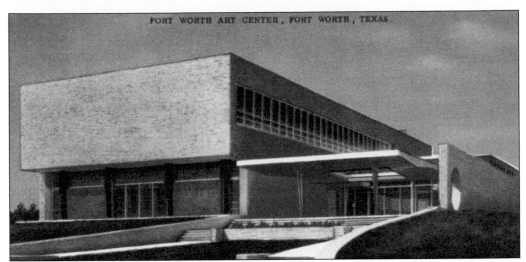

FORT WORTH ART CENTER. The Fort Worth Art Association began as a committee of the Carnegie Library Board in 1910 to fulfill part of the library charter that called for the "establishment and maintenance of a free public Art Museum in Fort Worth." By 1928 the association had acquired a varied collection that included everything from classical paintings to fossils. The collection continued to be housed in the library after the Carnegie Library was demolished and a new library was built in 1938. Having outgrown its space by 1950 the association commissioned Herbert Bayer to design a new modern building on city-owned land near the Will Rogers complex. Opened to the public in October 1954, the building housed the collections until the 2002 move to the inspired Tadao Ando-designed museum across the street from the Kimbell Art Museum. The former art center building now houses the Fort Worth Community Arts Center. (Metrocraft, *c.* 1954.)

A MOMENT WITH HELEN AND THE TWINS. In 1935 a young actress named Frances Helen made radio history in Fort Worth when she beat out 62 other women for the lead in the early soap opera "Helen's Home." A staple for listeners throughout WBAP's huge broadcast area, the show was such a hit that Lever Brothers picked up the sponsorship and packed the cast off to New York. When World War II broke out Frances Helen joined the Women's Air Corps and left her radio job behind. She returned to Fort Worth after the war, went back to work for WBAP, and by 1947 was the station's Director of Women's Programs. This promotional card was sent with "Regards" from Helen to a fan in Lindale, Texas. (Unknown Publisher, *c.* 1950.)

113

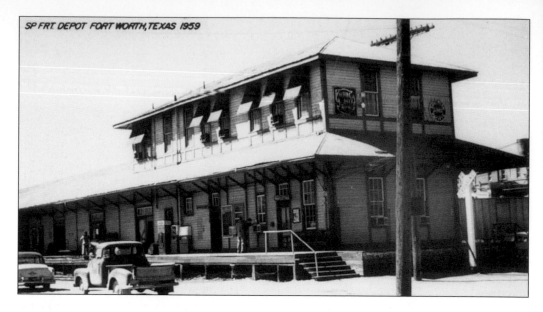

SP FRT. DEPOT FORT WORTH, TEXAS 1959

THE SOUTHERN PACIFIC RAILROAD. At the time the images on this page were taken in 1959 components of the Southern Pacific had operated in Fort Worth since 1885. Starting with the Fort Worth and New Orleans, and later with the acquisition of the Houston and Texas Central, the Southern Pacific developed an extensive yard operation on the city's southeast side. Pictured above is the 1892 freight depot built originally for the H&TC and used until the early 1980s when it was retired. Demolished in 2001, it was probably the oldest remaining railroad building in Fort Worth., a reminder of the push by Fort Worth leaders to make the city a national rail center. The Southern Pacific legacy is carried on by the Union Pacific, which spent $5.4 billion to acquire its competitor in 1996, and now operates at the Centennial Yard, one of largest freight classification systems in the country. (Harold D. Conner, 1959.)

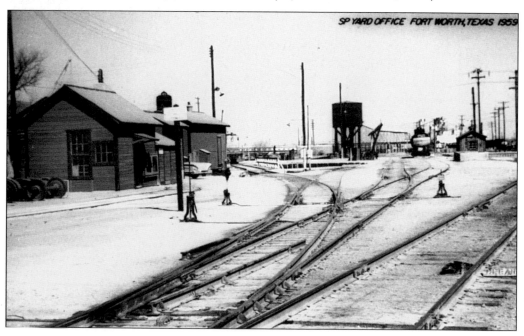

SP YARD OFFICE FORT WORTH, TEXAS 1959

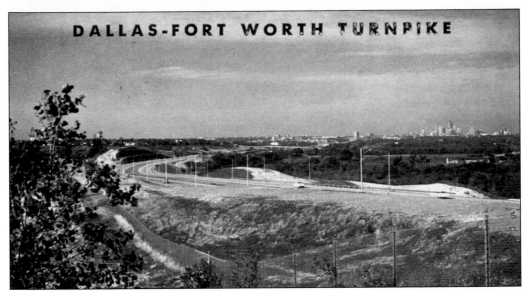

THE DALLAS FORT WORTH TURNPIKE. Following in the traditions of the T&P railroad, the Interurban, and U.S. Highway 80, the turnpike offered the next step in connecting Fort Worth and Dallas. Printed to commemorate the completion of the project and to encourage new riders, the card reads, "Officially opened August 27, 1957, this outstanding $58.5 million highway facility breezes 30 miles through picturesque countryside to connect the downtown districts of Dallas and Fort Worth." (Stryker Western Fotocolor, 1957.)

M&O SUBWAY. As suburban stores with easy parking began to eat away at the old-line merchants downtown, one store met the challenge head on. Obie and Marvin Leonard decided to build a subway to move customers from the store's remote lot to a refurbished and expanded Leonard's. The M&O Subway made its first run in February 1963 following the construction of a tunnel requiring the removal of more than 40,000 tons of dirt and rock. Tandy Corporation/Radio Shack continued to offer the free subway until 2002 when the company began construction of a new corporate campus and the first phase of a planned riverfront development. (Stryker Western Fotocolor, *c.* 1963.)

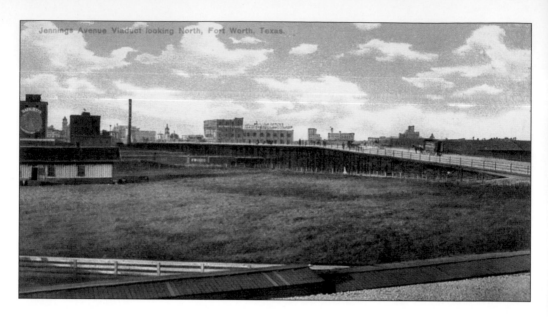

JENNINGS AVENUE. These two images, made 25 years apart, illustrate the tremendous change going on in Fort Worth between 1905 and 1930. The Jennings Avenue Viaduct, seen above, was the primary entrance to downtown Fort Worth from the south side. A similar bridge crossed the track at Hill Street, later Summit Avenue. In this view, the spire of St. Ignatius can be seen left of center as nearly the tallest structure at that end of town. By 1930 the city and railroad had completed the bridge and road improvements launched in 1928. The old viaduct was replaced with a new underpass similar to the ones at Main and Henderson Streets. The skyline shows the results of the building boom of the 1920s and, with the exception of St. Ignatius, almost everything pictured in the earlier view had been replaced by new construction. (Top: Elite Post Card Co., *c.* 1907; Bottom: Curt Teich, *c.* 1933.)

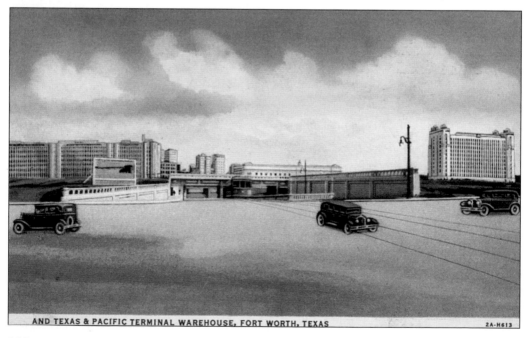

AND TEXAS & PACIFIC TERMINAL WAREHOUSE, FORT WORTH, TEXAS 2A-H613

Eight
TRANSITIONS

NEVER ENOUGH TIME. The Electric Post Card Studio at 1309 Main Street did a land office business producing photo postcards for its customers. Just four blocks up the street from the train station, the studio provided a wide variety of backdrops and props, allowing people to sit for both serious and whimsical portraits. Here, an unidentified young man, pipe firmly clenched in his mouth, checks his watch while a train ticket rests safely inside his straw hat. Never mailed, perhaps the card was intended to let family or friends know that this fellow had made good in the big city and was on his way home for a visit. (Electric Post Card Studio, c. 1920.)

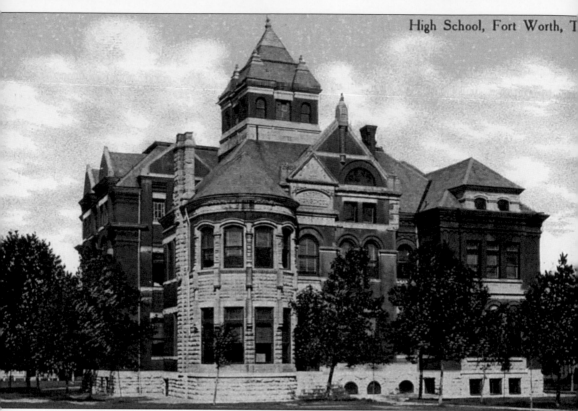

FORT WORTH HIGH SCHOOL. The changes in architectural styles pictured here mirrored the changes in the delivery of education as Fort Worth grew. The view above shows the Fort Worth High School built in 1891 on South Jennings between Jarvis and Daggett Streets. Considered state of the art when it opened, the building not only held classrooms, but the school system administration as well. It escaped the Southside Fire in 1909, but burned in December 1910. The Justin Boot factory sits on the site today. Even before the fire, school leaders had planned construction of a new and bigger high school to accommodate the swelling numbers of students and had acquired land a few blocks down Jennings Street. The Waller and Field designed building, shown above right, was completed in 1911. Growing numbers required the division of high school students and the construction of new schools, including the new Central High School in 1918. Central, shown lower right, was built on the land vacated by the Old Fort Worth University when it closed in the city in 1910. It was renamed for longtime high school principal R.L. Paschal, and later for Green B. Trimble, and operates today as the school district's Technical High School. The 1911 building was successfully converted to apartments after years of sitting empty and protected by a developer whose refusal to sell the building spared it from demolition. (Top: S.H. Kress Co., *c.* 1908; top right: F.W. Woolworth Co., *c.* 1911; bottom right: Curt Teich, *c.* 1928.)

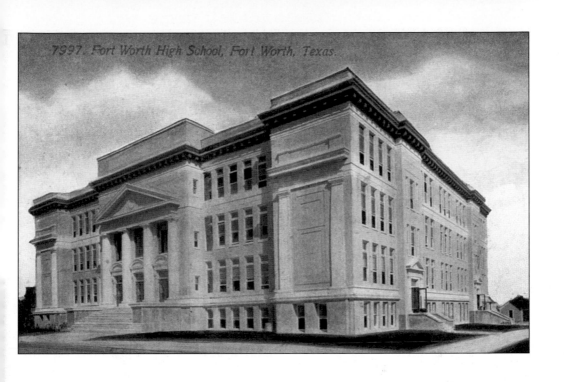

7997. Fort Worth High School, Fort Worth, Texas.

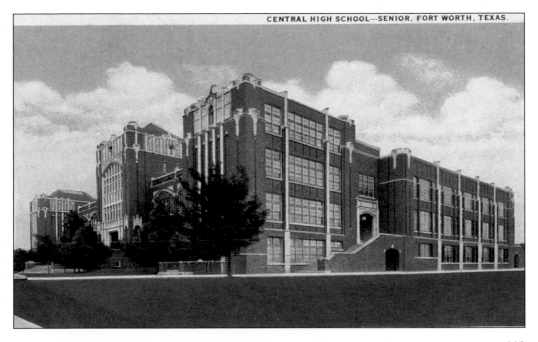

CENTRAL HIGH SCHOOL—SENIOR, FORT WORTH, TEXAS.

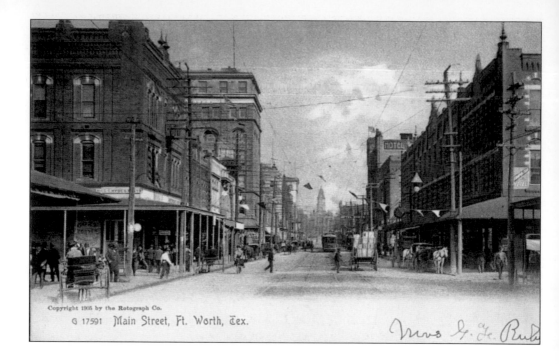

Copyright 1905 by the Rotograph Co.

G 17591 Main Street, Ft. Worth, Tex.

MAIN STREET. These four views of Main Street chronicle the changes along the city's central corridor between 1905 and 1960. Remarkably, several buildings survived the intervening years and still stand as tangible reminders of the periods of growth and depression, challenge, and triumph. Fort Worth's Main Street today is the envy of cities around the country trying to

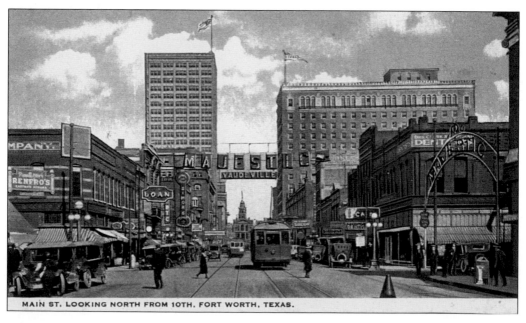

MAIN ST. LOOKING NORTH FROM 10TH, FORT WORTH, TEXAS.

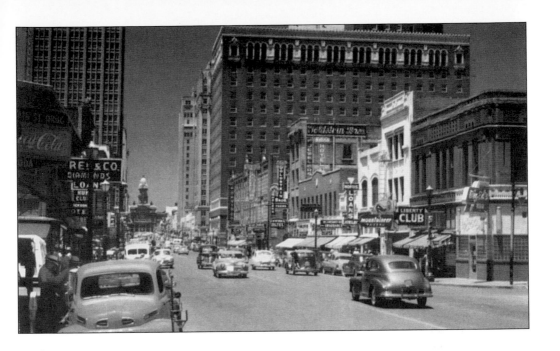

replicate the energy and vitality of a downtown reborn. The image top left looks down Main Street toward the Courthouse in 1905. The image below left takes a similar view about 1920. At top right is a view taken in 1951 and, at lower right, the view past the demolished Metropolitan Hotel was taken about 1960. (Top left: Rotograph Co., 1905; bottom left: Seawall Specialty Co., c. 1920; top right: Texacolor, 1951; bottom left: Stryker's Western Fotocolor, c. 1960.)

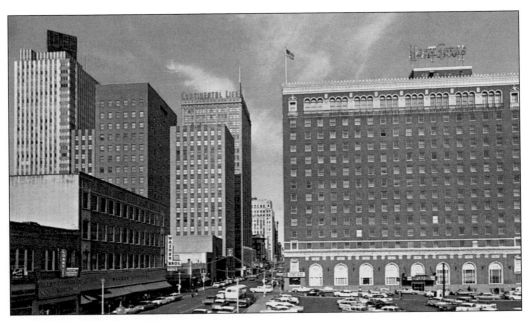

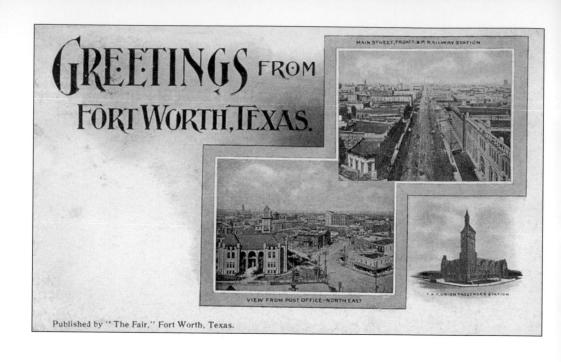

GREETINGS FROM FORT WORTH, TEXAS.

MAIN STREET, FROM T. & P. RAILWAY STATION

VIEW FROM POST OFFICE—NORTH EAST

T. & P. UNION PASSENGER STATION

Published by "The Fair," Fort Worth, Texas.

Greetings from Ft. Worth, Texas

GREETINGS FROM FORT WORTH. The tradition of including several views of the city follows through each period of postcard development. The four cards shown here depicted the best attractions the town had to offer at the time. The earlier cards showcase the old T&P Depot, city hall, and the federal building, while the later views tout the Will Rogers Tower, Meacham Airport, the Botanic Gardens, and the Zoo. The wonderful card at lower right demonstrates a homemade flair with images carefully cut and pasted before the final card was photographed for production. (Top left: The Fair, *c.* 1903; bottom left: The Fair, *c.* 1905; top right: E.C. Kropp, *c.* 1940; Bottom right: M. Martin, 1954.)

FORT WORTH. The generic card above, overprinted for Fort Worth, with its 1920s sweetness and warmth, provides quite a contrast to the promotional card issued by the Stockyards merchants in 1955. As part of the early campaign that would lead the Fort Worth Stockyards to become one of the most popular western oriented historic districts in the country, the North Fort Worth Businessmen's Association found the toughest face they could to help entice visitors. Not quite the warm reception expected in 1920, but it worked. (Top: J.M.P., c. 1920; bottom: Unknown Publisher, c. 1955.)

AFTERWORD

One of the most repeated comments I hear when I give tours of Fort Worth is "I've lived here for years, and I've never noticed this." The wonderful and unique history of the city is all around us—in the parks, in the buildings, and in the geography that dictated how the city grew. If this little book accomplishes nothing else, I hope it sparks a few readers to get out and explore. Tarrant County and Fort Worth have more official and unofficial historical markers than anywhere else in the State of Texas. No other city combines so many pieces of the legendary West—the frontier fort, the trail drives, the railroad, ranching, and oil—and nowhere else is that history more accessible, thanks in large measure to the work of the authors and historians whose research made my effort here possible.

My favorite place in the city is Lake Worth. There are more images of the lake included in this book than any other subject, but I have added a few more facts for those who might be interested. At some point in the not too distant future, Lake Worth will literally sit in the middle of the city and could, with vision and careful planning, become an urban park resource unique in the country.

Lake Worth was once the premier park in the Southwest. Its popularity as a destination declined with the development of municipal swimming pools, air-conditioning, television, and the distractions of modern life. As Fort Worth grows to surround this urban park, its treasures will again attract visitors to the natural settings and the magnificent landscapes so carefully designed and painstakingly executed. A drive around Lake Worth today is as inspirational as it was when the first cars rolled along Meandering Road in 1917, and Fort Worth families discovered the wonders of nature in the city's own backyard.

Amon Carter opened his famous Shady Oaks Farm on 900 acres on Lake Worth in 1923. Over the next thirty years, Carter would host virtually every major dignitary who visited Fort Worth, including several presidents. The famous "Frontier Bar" is described in the WPA Guide to Fort Worth: "Immediately beyond the farm house is the Frontier Bar, with a sign 'Howdy Stranger' over its front; this was the gateway to the 1936 Fort Worth Frontier Fiesta . . . Scattered over the walls are crude signs reminiscent of early Texas such as: 'No shooting, check your pistol.' 'No checks cashed not even good ones.' 'Dallas passport must be okayed.' On the walls are mounted specimens of native longhorn steers, one of which entertains with ribald songs including a humorous tirade against Dallas, Texas and during its rendition, the steer symbolic of Carter's hatred of Fort Worth's sister city will emit snorts and smoke from its nostrils." Nothing remains today of the famous farm except a few foundations and the small stock pond.

In 1934, the city commissioned the nationally renowned Kansas City landscape design firm of

Hare and Hare to develop a comprehensive design for the city's parks, including Lake Worth. The firm developed a plan for the lake that would create picnic areas, sheltered pavilions and long vistas. The plans became a reality with the opening of Camp 1816 of the Civilian Conservation Corps. Between 1934 and 1937, the men of the CCC constructed roads, built bridges, and completed most of the recommendations in the Hare and Hare plan. Twenty stone picnic areas were built, along with restroom facilities and water fountains. Rocks cut from the cliffs along the lakeshore decorated drainage culverts and nature trails and were used to build magnificent shelter houses and lookouts. A monument in the Fort Worth Nature Center, on the northwest end of the lake, chronicles the tremendous work of the CCC.

Other milestones in the lake's history include the founding of the Fort Worth Boat Club in 1929 and the Lake Worth Sailing Club in 1935. In 1928, with help of Fort Worth Congressman Fritz Lanham, the federal government opened the largest fish hatchery in the Southwest just below the dam. Today the facility is managed by the Texas Parks and Wildlife Department. In 1943 dozens of seaplanes were flown onto the lake from their bases along the Texas coast to protect them from a possible hurricane. Shortly after the World War II, a B-36 crashed into the

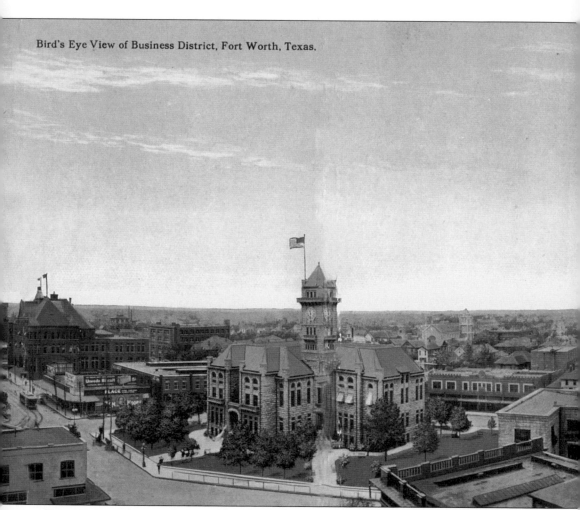

Bird's Eye View of Business District, Fort Worth, Texas.

PANORAMA. This rare four-panel panoramic view of Fort Worth, *c.* 1907, was taken from the roof of the new Flatiron Building. It provides a nearly 180-degree view from Jennings Avenue

hillside across the lake from the Convair Plant, and during the Cold War, the hills surrounding the lake were dotted with missile sites to protect the military operations in Fort Worth.

Over its 90 years, Lake Worth has gone from being a cherished municipal asset to a mostly forgotten treasure, its carefully crafted design hidden by undergrowth and threatened by plans that largely ignore its unique place in the city's history. As Fort Worth moves to better preserve its historic resources with the 2003 adoption of a Citywide Historic Preservation Plan, it has never been more important to explore and identify those resources and to maintain the discipline to protect them against the pressures of a growing city. I hope this book helps.

on the left around to Houston Street at the far right. (S.H. Kress Co., *c.* 1911.)

Bibliography

Bond, Lewis H. *Century One: 1873–1973 A City and the Bank that Bears Its Name.* The Newcomen Society in North America, 1973.

Brooks, Elston. *With A Cast Of Thousands.* Fort Worth: Branch-Smith, Inc., 1982.

———. *Don't Dry-Clean My Blackjack.* Fort Worth: Branch-Smith, Inc., 1979.

Buenger, Victoria and Walter L. *Texas Merchant; Marvin Leonard & Fort Worth.* College Station: Texas A&M University Press,1998.

City Directories 1880–1960. Fort Worth Public Library.

City of Fort Worth. *www.fortworthtimeline.org.*

Cohen, Judith Singer. *Cowtown Moderne.* College Station:Texas A&M University Press, 1988.

Cuellar, Carlos E. *Stories from the Barrio; A History of Mexican Fort Worth.* Fort Worth: Texas Christian University Press, 2003.

Duringer, Dr. William C. *A Pioneer Doctor's Story.* Fort Worth: Paul Printing Co., 1963.

Evans, James Hunt Jr. *A History of the Masonic Temple of Fort Worth.* Fort Worth: Perkco Co. Subsidiary of Stafford-Lowden Co. Printers, 1977.

Farman, Irvin. *The Fort Worth Club: A Centennial Story.* Fort Worth: Motheral Printing Company, 1985.

Federal Writers' Project. *Research Data, 77 vols.* Fort Worth Public Library, 1941.

Flemmons, Jerry. *Amon: The Life of Amon Carter Sr. of Texas.* Austin: Jenkins Publishing Company, 1978.

The Fort Worth Chamber of Commerce. *Five Years of Progress, 1928–1932 Fort Worth 50th Anniversary Commemorative Re-Issue.* Fort Worth: Stafford-Lowden Co. and Kenneth Groves and Pat Taylor,1982.

Garrett, Kathryn and Mary Daggett Lake. eds. *Down Historic Trails of Fort Worth and Tarrant County.* Fort Worth: Dudley Hodgkins Company, 1949.

Hall, Colby D. *History of Texas Christian University.* Fort Worth: Texas Christian University Press, 1947.

Hall, Flem. *Sports Champions of Fort Worth, Texas 1868–1968.* Fort Worth John L. Lewis, Publisher, 1968.

Havard, Gary L. and Don A. Ryan. *Cowtown U.S.A.* Fort Worth: Identity Arts, 1976.

Hulme, Louie L., ed. *Rotary Club of Fort Worth, Seventy-fifth Anniversary 1913–1988.* Rotary Club of Fort Worth, 1988.

Jary, William E. Jr., ed. *Camp Bowie Fort Worth 1917–1918.* Fort Worth: B.B. Maxfield Foundation, 1975.

Jones, Jan. *Billy Rose Presents…Casa Manana.* Fort Worth: Texas Christian University Press, 1999.

King, Steve M. *The Tarrant County Courthouse A Self-Guided Walking Tour.* Tarrant County, Texas, 1995.

Knight, Oliver. *Fort Worth Outpost on the Trinity.* Norman: University of Oklahoma Press, 1953.

Magnus, Werner. *Who Was Hulen?* Fort Worth: Bill Hanson Printing, Inc., 1990.

Noah, Jim. *Backfires, A Cartoon History of the Fort Worth Fire Department.* Fort Worth: Jim Noah, 1981.

Oates, Paula, ed. *Celebrating 150 Years: The Pictorial History of Fort Worth, Texas 1849–1999.* Fort Worth: Landmark Publishing, Inc., 1999.

Pate, J'Nell. *Livestock Legacy The Fort Worth Stockyards.* College Station: Texas A&M University Press, 1988.

Pate, J'Nell. *North of the River.* Fort Worth: Texas Christian University Press, 1994.

Patterson, Mike. *Fort Worth, New Frontiers in Excellence.* Chatsworth, CA.: Windsor Publications, Inc., 1990.

Payne, Darwin & Kathy Fitzpatrick. *From Prairie to Planes.* Dallas: Three Forks Press, 1999.

Perkins, Charles R. *History of Fort Worth Lodge No. 148, A.F. & A.M.* Fort Worth: Department of Printing Masonic Home and School,1958.

Pirtle, Caleb, III. *Fort Worth; The Civilized West.* Tulsa: Continental Heritage Press Inc., 1980.

Porter, Roze McCoy. *Thistle Hill, The Cattle Baron's Legacy.* Fort Worth: Branch-Smith, 1980.

Reeves, Dr. L.H. *The Medical History of Fort Worth and Tarrant County One Hundred Years 1853–1953.* Fort Worth: Tarrant County Medical Society, 1953.

Reynolds, Clay with Marie-Madeleine Schien. *A Hundred Years of Heroes; A History of the Southwestern Exposition and Livestock Show.* Fort Worth: Texas Christian University Press, 1995.

Roark, Carol and Rodger Mallison. *Fort Worth, Then & Now.* Fort Worth: Texas Christian University Press, Fort Worth, 2001.

Roark, Carol and Byrd Williams. *Fort Worth's Legendary Landmarks.* Fort Worth: Texas Christian University Press, 1995.

Roark, Carol, ed. *Tarrant County Historic Resources Survey.* Fort Worth: Historic Preservation Council for Tarrant County, Texas, 1982–1991.

Roberts, John. *www.fortwortharchitecture.com.*

Roberts, Lesbia Word and the Historical Committee of the Fort Worth Petroleum Club. *Oil Legends of Fort Worth.* Taylor Publishing Company, 1993.

Sanders, Leonard and Ronnie C. Tyler. *How Fort Worth Became the Texasmost City.* Amon Carter Museum of Western Art, 1973.

Schmelzer, Janet L. *Where The West Begins, Fort Worth and Tarrant County.* Northridge, CA: Windsor Publications, Inc., 1985.

Schmidt, Ruby. *Fort Worth & Tarrant County A Historical Guide.* Fort Worth: Texas Christian University Press, 1984.

Texas State Historical Association. *The Handbook of Texas Online.*

Williams, Mack. *In Old Fort Worth.* Fort Worth: *The News Tribune,* 1976.